Tuscany and Umbria

Text by Stephen Brewer Updated by Christopher Catling Photography: Jon Davison: pages 3, 5, 6, 8, 11, 12, 13, 25, 26, 29, 31, 36, 39, 43, 44, 46, 47, 48, 51, 54, 57, 58, 61, 62, 64, 67, 69, 73, 75, 87, 88, 91, 95, 101; Daniel Vittet: pages 81 and 99; Italian Government Tourist Board: pages 9, 33, 52, 76, 78, 82, 84
Cover photograph by Richard Nowitz Layout: Media Content Marketing, Inc.

Cover photograph by Richard Nowitz
Layout: Media Content Marketing, Inc.
Cartography by Raffaele De Gennaro
Managing Editor: Tony Halliday

Fifth Edition 2002

NO part of this book may be reproduced, stored in a retrieval system or transmitted in any form or means electronic, mechanical, photocopying, recording or otherwise, without prior written permission from Apa Publications. Brief text quotations with use of photographs are exempted for book review purposes only.

CONTACTING THE EDITORS

Every effort has been made to provide accurate information in this publication, but changes are inevitable. The publisher cannot be responsible for any resulting loss, inconvenience or injury. We would appreciate it if readers would call our attention to any errors or outdated information by contacting Berlitz Publishing, PO Box 7910, London SE1 IVE, England. Fax: (44) 20 7403 0290; e-mail: berlitz@apaguidc.demon.co.uk

All Rights Reserved

© 2002 Apa Publications GmbH & Co. Verlag KG, Singapore Branch, Singapore Printed in Singapore by Insight Print Services (Pte) Ltd, 38 Joo Koon Road, Singapore 628990. Tel: (65) 6865-1600. Fax: (65) 6861-6438

Berlitz Trademark Reg. U.S. Patent Office and other countries. Marca Registrada. Used under licence from the Berlitz Investment Corporation

CONTENTS

Tuscany and Umbria	7
A Brief History	13
Where to Go	24
Florence Around Florence Pisa and the Coast Southern Tuscany Into Umbria	24 43 60 71 76

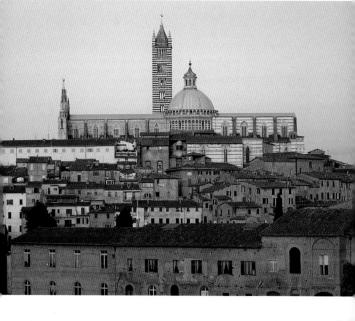

What to Do	85
Shopping	85
Festivals and Seasonal Events	89
Sports and Outdoor Activities	91
Music and the Performing Arts	92
Traveling with Children	93
Eating Out	94
Handy Travel Tips	105
Hotels and Restaurants	128
Index	143

• A lor in the text denotes a highly recommended sight

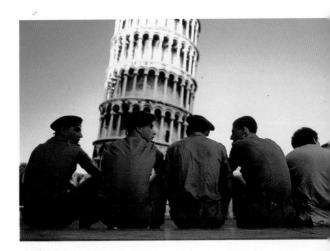

Tuscany and Umbria

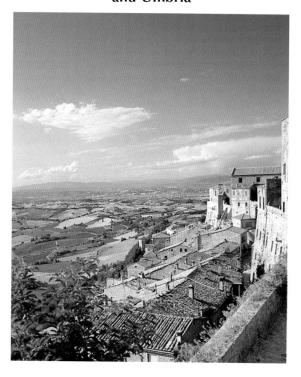

TUSCANS AND UMBRIANS

Be prepared to encounter what you might mistakenly interpret as arrogance as you travel through Tuscany and Umbria. Take the Florentines. They tend to think of themselves as residents of one of the most prosperous cities in Italy, as caretakers of the greatest repository of art treasures in the Western world, and as speakers of the purest form of Italian. Outside Florence (an appellation residents dislike, preferring, naturally, the Italian name for the city, Firenze), but still in Tuscany, you will meet people who think they live in Italy's most beautiful and bountiful region, produce some of the world's finest wines, and live in some of Europe's loveliest towns and villages.

Then there are the Umbrians. They will have you convinced in no time that their landscapes of rolling hills and gentle valleys are imbued with a special spiritual quality. After all, Saint Francis of Assisi, who may well be the world's most popular saint and who is in fact the patron saint of Italy, wandered this terrain and lived and died in the lovely, hill-clinging town of Assisi.

You will have a difficult time arguing with any of these claims. Florentines have indeed prospered since their merchants and trade guilds came of age in the Middle Ages. They do indeed have in their midst the greatest works of Michelangelo, Brunelleschi, Donatello, and other masters of the Renaissance (which, of course, took root here). They can rightfully claim that their dialect evolved into modern-day Italian, with the helping influence of Dante and other Florentine writers. And the rest of Tuscany is truly beautiful, its wines are sublime, and its medieval towns, crowning many a hilltop, fulfill just about any traveller's notions of what a European village should look like.

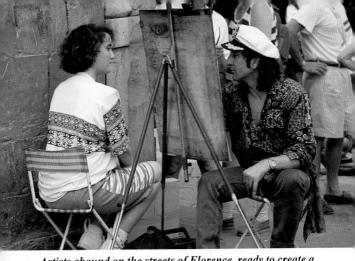

Artists abound on the streets of Florence, ready to create a lasting remembrance for any willing visitor.

As for Umbria—well, take yourself to Assisi, wander its medieval streets, admire the Giotto frescoes in the basilica dedicated to Saint Francis, and look out across the valley to the golden hills in the distance. Chances are that in so doing you'll get at least a hint of what is meant when it's said the region is spiritual.

What first strikes any traveller about Tuscany and Umbria is how attractive the regions are. The cypresses, olive trees, and vineyards, the hilltops crowned with tile-roofed houses and proud towers, the tilled soil that glows amber in the slanting sun: these are the backdrops of the Renaissance paintings you have seen in galleries around the world, and you will see the same landscapes unfolding before your eyes as you travel the roads of these regions. The landscapes inspired the paintings, and the paintings in turn prepare you for what you encounter.

Tuscans and Umbrians

Nor should you be surprised to see familiar faces. A young woman in Arezzo might resemble a Madonna in a canvas by Piero della Francesca, or a man behind a market stall in Florence could pass for a figure in a Uccello fresco. The Renaissance painters did, after all, paint what they saw around them, and it's no small point of pride in these parts that the ancestors of today's Tuscans and Umbrians were part of Europe's great reawakening.

Given the regions' representation in countless works of art, a traveller's perceptions of Tuscany and Umbria are usually of countryside punctuated now and then by medieval towns and of cities rising from fields and vineyards. In some cases—in fact, in many cases—reality doesn't disappoint. Some of the most memorable views in the world must be (and this is just a short list) the towers of San Gimignano rising out of the golden fields as you approach the town from Volterra, the ochre-tiled roofs of Siena floating above the lush vineyards of Chianti,

Orvieto cascading across its mountaintop above the undulating Umbrian countryside below, and, of course, Brunelleschi's dome signaling your approach to Florence before the rest of the city comes into view.

But 20th-century progress has often left its mark as well. While these regions remain primarily rural, as they have

Siena is a town of the Middle Ages: its architecture should not be missed.

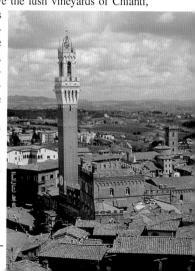

been since the Etruscans, fewer people work the land now than they did even 50 years ago. The *contadini*, the farmers who for centuries tilled the soil and were required to give half the bounty to often-absentee landlords, are now either landowners themselves or have given up farming altogether. They may now commute from their land to jobs in the city, or their farmhouses may be vacation homes for people from northern Europe or Rome or New York. Industry has encroached on the countryside (especially in the valleys around Florence), and many towns and cities have outgrown their original walls and are now surrounded by modern suburbs.

Tuscans and Umbrians, however, are never too far removed from their rural roots. A walk in the country is still the favored pastime of city dwellers, and a patch of tomatoes and maybe a henhouse occupy the corner of many apartment terraces and suburban plots. In many places, careful zoning keeps sprawl to well-defined sectors—even in ever-expanding cities like Florence and Perugia you can still look from a belvedere over scenery that is primarily rural. In short, Tuscany and Umbria are real places, prosperous but rural at their core, with latter-day intrusions. Part of the pleasure of travelling here is seeing how well the rural and the urban, the old and the new, coexist.

In the post-World War II years, Tuscans and Umbrians have learned how to interact with another modern phenomenon—tourism. Not that travellers hadn't long ago discovered the pleasures of Florence and the other art-rich Tuscan and Umbrian cities. Read E. M. Forster's *A Room with a View* to see what a profound effect Florence had on British Edwardians, and travellers had preceded them for centuries. Carrying on their merchant traditions, Florentines have been especially wily at dealing with their visitors, not always to the benefit of the latter. One too many inflated restaurant tabs and one too many postcard stalls may have you vowing to leave the city and never return.

Tuscans and Umbrians

But avoid the city and such popular outlying meccas as San Gimignano during their most-visited summer months, and you will have a different impression altogether. Or simply head out for quieter places, which are never far from the fray. One of the best antidotes to summertime Florence is a retreat to hilltop Fiesole, where you will also be rewarded with a stunning view, a glimpse of fascinating Roman ruins, and a cooling breeze.

When it comes to determining how to plan the logistics of your travels in Tuscany and Umbria, you are both blessed and cursed. For better or worse, and to understate the case, there is just so much to see. Fortunately, the regions are compact

The Ponte Vecchio is a lovely sight at any time of day, but even more so during a Florentine sunset.

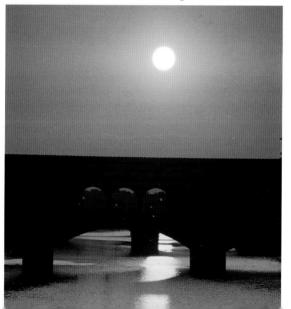

Lush landscapes of rolling Tuscan hills dotted with farmhouses will stay with you long after you return home.

enough that you can travel through them with ease, and the road and train networks are excellent.

You may want to divide the regions into segments to be savoured in forays from several bases of operation. From Florence you can explore Pisa and Lucca, as well as lesser-known Prato and Pistoia, and the Chianti countryside to the south. From Siena you can follow a spur of the Apennines that separates the central valleys of Italy from the Mediterranean coast and explore a string of hill towns that include San Gimignano, Volterra, and Montepulciano. The centuries-old university town of Perugia is a perfect base from which to set out for Gubbio, Assisi, Spoleto, Orvieto... and the list could go on.

Everyone seems to find the corner of Tuscany and Umbria that immediately becomes a favourite place. It might be the narrow medieval streets of Florence or Perugia, or a palazzo overlooking a quiet piazza in Montalcino or Gubbio, or a lonely farmhouse in the lush farmland around Pienza or Todi. But rest assured: somewhere in Tuscany or Umbria you are going to find a place that will be with you for the rest of your life and to which you will want to return again and again.

A BRIEF HISTORY

early three thousand years ago, an advanced Etruscan culture was thriving in the hilly terrain around present-day Volterra in western Tuscany. On 25 March 1436, Florence celebrated the completion of the dome that crowns its cathedral; the construction of this massive drum was one of the great architectural achievements of the Renaissance. On 4 August 1500, in Perugia, members of Baglioni clan, muddled by decades of intermarriage and inflamed by vendettas, turned on one another in an internecine massacre that left more than 100 people dead—just one of many such episodes in the traumatic history of this elegant city built on an Umbrian hilltop.

Extraordinary as they are, each of these historical anecdotes is but a tiny piece of the amazing fabric of events that have tran-

Vestiges of Tuscany's ancient Etruscan city still stand: here, the 13th-century gate to Colle di Val d'Elsa.

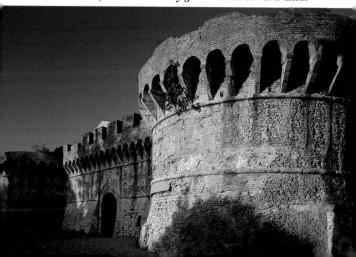

spired in the relatively small geographic confines of Tuscany and Umbria. For the traveller, it's one thing to know that such events once unfolded here. Even more satisfying is the fact that most of the venues where the transgressions and triumphs of Tuscan and Umbrian history have played out can still be visited.

Much of what the Etruscans left behind is on display in Volterra's Museo Guarnacci. The magnificent dome still rises high above Florence as if to announce that, yes, this is where the Renaissance, with all its similar achievements, bloomed and flowered. And while Perugia has been taken and retaken time and again in the intervening centuries, the cathedral and adjoining piazza where the bloodbath of the Baglionis occurred still stand proud.

Tuscany

The first chapter of Tuscan history belongs to Etruscan tribes known as the Tusci, and accordingly the region took their name. Enough remains unknown about the Etruscans to render them "mysterious". Some scholars say they migrated to Italy from what is now Anatolia in central Turkey; others say they were indigenous to the Italian peninsula. Some maintain they were an enlightened civilisation that embraced democratic ideals, others that theirs was a slave-based and war-like society. Some claim that the elaborate burial urns on display in so many Tuscan museums are evidence that the Etruscans had an enormous respect for human life, others that they were obsessed with death and the afterlife and put little value on the here and now. What is known is that their sculpture and painting, as you will see for yourself, were classically refined.

From Romans to Guelfs and Ghibellines

By 59 B.C., when Julius Caesar established the colony of Florentia as a sort of retirement community for veterans (a clever

Historical Highlights

800-500 B.C. Etruscans thrive in what is now Tuscany

and Umbria.

59 B.C. Rome, long since having conquered central Italy, establishes an outpost called Flo-

al Italy, establishes an outpost called Flo

rentia, later Florence.

Mid-sixthninth centuries

1200

1504

Lombards and Franks control much of what is now Tuscany and Umbria.

Conflicts between Guelfs and Ghibellines divide loyalties; most towns are indepen-

dent, free communities.

1226 Saint Francis of Assisi, patron saint of

Italy, dies, leaving behind a message of

love and virtue.

1250-1600 The Renaissance flowers, re-civilising the

Western world.

14th century Florence, growing more powerful, conquers Arezzo, Volterra, other cities and towns.

14th-17th Umbrian cities come under the power

centuries of the papacy.

1348 The Plague decimates populations of Flo-

rence and Siena.

Inspired by the ascetic monk Savonarola,

Florentines renounce and burn material possessions on "Bonfires of Vanity" in Piazza della Signoria; the monk himself is burned

at the stake three years later. Michelangelo completes David.

1581 The Uffizi Gallery opens.

1860s Tuscany and Umbria become part of unified Italy. Florence serves as capital from

1865 to 1870.

1944 Germans destroy all bridges in Florence

except the Ponte Vecchio.

Floodwaters ravage Florentine art treasures.
A bomb rips through the Uffizi galleries.
Earthquakes shake Umbria, destroying

Larinquakes snake Ombria, destroyii

frescoes in Assisi's basilica.

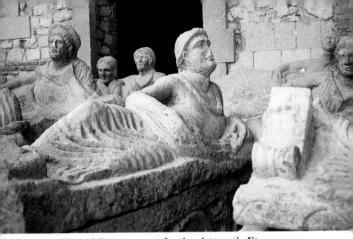

On their elaborate sarcophagi, aristocratic Etruscans recline in dignified repose.

way to maintain order in outlying provinces), the Etruscans had long been gone, overrun by the joint menace of the Romans from the south and the Gauls from the north. As invasions from Goths and later Byzantine armies in turn put an end to control from Rome and laid settlements across Italy asunder, much of the region re-emerged under the stable influence of the Lombards.

The next wave of unrest to ripple across Tuscany resulted from the Guelf-Ghibelline struggles, in essence a scramble for power between the temporal leaders of the Holy Roman Empire (the Ghibellines) and the Pope and his supporters (the Guelfs). Florence's sympathies were with the Guelfs; most of the city's rivals, including Pisa and Siena, were Ghibelline. Florence attained the ascendancy as the fortunes of Pisa, once a great maritime power, waned when Genoa triumphed at sea, and as Cosimo di Medici, scion of Europe's greatest

banking family, led Florence to final victory over its one remaining rival, Siena, in 1557.

The Renaissance

In the meantime and amid all this strife, Florentines were engaging in a frenzy of activity that would pull western civilisation out of the Dark Ages. The Renaissance took root in Florence, under the patronage of the Medici clan, who, with some bloody interruptions, continued to rule Florence and most of Tuscany until the middle of the 18th century.

At every turn you can trace the development of this movement that, in a nutshell, emancipated humankind to look at the world in an enlightened way. In the Uffizi, the art gallery Florence founded in the 16th century, you will see how the painter Uccello became one of the first to master that great Renaissance contribution, perspective, and in the church of San Lorenzo you'll see how the architect Brunelleschi introduced a new order to spatial relationships. In the Accademia, you need

only look at that most famous of all Renaissance sculptures, Michelangelo's *David*, to see how the Renaissance revolutionised the way sculptors looked at the human form.

To Unification and the 20th Century

Despite these amazing accomplishments, Florence

Lorenzo de Medici, the patron behind Botticelli and Sangallo.

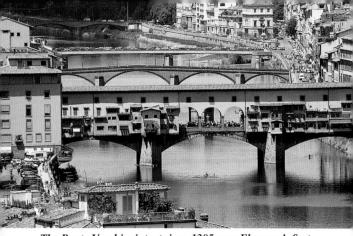

The Ponte Vecchio, intact since 1385, was Florence's first bridge and, for centuries, the only one.

and the rest of Tuscany slumbered through the post-Renaissance years as a backwater, a pawn to greater European powers. In 1860, after more than a century of capable rule by the house of Lorraine, Tuscany joined forces with Piedmont as part of a united Italy. Florence, in fact, served as the Italian capital from 1865 to 1871.

The absence of old bridges across the Arno attests to the largest single event in 20th-century Tuscan history—World War II. Some of the major battles in the European theatre took place in and around Florence in the summer of 1944, when the Germans entrenched themselves along the Arno and in the surrounding mountains as the Allies advanced. The Germans retreated in August, but not before blowing up all but one of Florence's beloved bridges, the Ponte Vecchio.

The world's attention turned to the Arno again in November 1966, when the river burst its banks and floodwaters rav-

aged many of the city's art treasures. Restoration efforts continued for decades, fuelled no doubt by the Florentines' belief that they are protectors of the Renaissance heritage their forebears fostered. These same custodial efforts came into play again in May 1993, when a car bomb ripped through parts of the Uffizi galleries; within months, the damage had been repaired and the museum, a treasure house of the Renaissance, had reopened its doors.

Umbria

Just as the Renaissance was the great defining influence of Florence and Tuscany, the emergence of Christianity shaped Umbria. As you travel through this rolling landscape—and certainly at Assisi, the most religious place in Umbria—time and again you will come upon evidence of just how much the church determined the shape and fortunes of this region.

Long before Christianity swept through Umbria, it was inhabited by agricultural tribes, one of which, the Umbrians, left their name. They retreated with the arrival of the Etruscans, who in turn were routed by the Romans. Even before the Empire went into decline, however, Christianity was gaining a stronghold in the Umbrian countryside. The first monastery was established near Spoleto in the first century A.D.; four hundred years later, as the power of Rome crumbled, Saint Benedict founded one of the first religious orders, ensuring some semblance of order in an increasingly barbarian world.

Saint Francis and Christian Teaching

Christianity continued to influence the region in two distinct ways. On the one hand, simple Christian teachings took unusually deep roots in the rural outposts of Umbria. Then, too, there was the worldly and often oppressive presence of the Papacy.

Movers and Shakers of the Renaissance

One of the pleasures of touring Florence and the rest of Tuscany and Umbria is encountering the masterpieces of the regions' artists. They are only a few of the great Renaissance masters, but are certainly among the most influential. Study their works and you will begin to comprehend the genius that kindled the reawakening of Europe and Western civilisation.

Filippo Brunelleschi (1377–1446) began his career as a sculptor. Thwarted by his failure to obtain a commission to design the doors of Florence's baptistery, he travelled to Rome to study Classical architecture and returned to Florence to create some of that city's greatest Renaissance monuments. These include the dome of the Duomo and the churches of San Lorenzo and Santo Spirito.

Luca della Robbia (1400–1482) perfected techniques for glazing clay sculpture. The results are the blue, white, and yellow terra-cotta compositions you'll see at the Bargello and Santa Croce in Florence. His nephew Andrea and Andrea's son Giovanni carried on the tradition; as a result, the hallmark della Robbia terra-cottas adorn buildings throughout Tuscany.

Donatello (1386–1466) left his contributions to sculpture—and he was undeniably the greatest Renaissance sculptor—throughout Florence. His relief of *Saint George* in the Bargello is one of the earliest examples of the use of perspective, and his *David* in the Bargello is one of the first Renaissance nudes.

Lorenzo Ghiberti (1378–1455) was commissioned to sculpt the doors of the Baptistery in Florence—a task that consumed most of his career, but such a great accomplishment are they that the one on the east wall inspired Michelangelo to exclaim that he was looking at the Gate of Paradise.

Domenico Ghirlandaio (1449–1494) was a teacher of Michelangelo, but is remembered best for his magnificent, humanist frescoes (which often depict the local citizenry in a less than flattering way), especially those in Florence's Santa Triníta and Santa Maria Novella.

Giotto di Bondone (1266–1337) transformed religious art into realistic portrayals of the world around us, and in so doing became the first great painter of the Renaissance. As you'll see in his fresco cycle depicting the life of Saint Francis in Assisi, he introduced such concepts as spatial relationships and the portrayal of human emotion.

Michelangelo (1475–1564) was still a young man when he secured his reputation with the *Pieta* in St. Peter's in Rome. He was to return there to work on the ceiling of the Sistine Chapel, but not before he enriched Florence with such works as *David*, now in the Galleria dell'Accademia.

Perugino (1445–1523) is perhaps the greatest of the Umbrian painters; you'll see the best of his work in the Umbrian city of Perugia, for which he was named. Limpid skies and ethereal landscapes, expressive of spirituality, are his trademark.

Piero della Francesca (1420–1492) left his mark throughout Tuscany and Umbria. In the frescoes he painted in the basilica in Arezzo you'll see his skills at perspective and conveying emotion in a restrained way, and his feeling for narrative drama.

Paolo Uccello's (1396–1475) first great work in Florence was his fresco portrait of Sir John Hawkwood, the English mercenary. As you admire this masterpiece in the Duomo and his later work, *The Battle of San Romano*, in the Uffizi, you'll note his concern for perspective.

Giorgio Vasari (1511–1574) is remembered not so much for his accomplishments as a painter or even as an architect (he designed the Uffizi Gallery), but for his accounts of masters more talented than he was. His *Lives of the Artists* is Europe's first work of art history.

Andrea del Verrocchio (1435–1488) succeeded Donatello as Florence's sculptor of note. His works are in the Uffizi, the Bargello, and other museums and churches throughout the city.

No one embodies Christian teaching with as much appeal as Saint Francis, born in Assisi in 1182. When he was 27, Francis received a call to give his life to God; he renounced his sizable inheritance (by stripping off his clothes in Assisi's Piazza del Comune), dressed himself in sackcloth, and began to preach a two-part message. He urged his growing body of followers to renounce material possessions and pledge obedience to God and, in a refreshing departure from the fire and brimstone that had characterised much church teaching until then, to appreciate the beauty of the natural world, which is, after all, God's creation. Francis founded an order and took his message across Europe and to the Holy Land with the crusaders. He died on the floor of his hut in Assisi in 1226 and two years later was canonised a saint. Ever since, Assisi has been one of Italy's, and the world's, holiest places.

Centuries of Papal Rule

Then there was the papal influence on Umbria. As the Papal States took control over much of Italy, popes sent armies to Umbria to conquer its proud hill towns. Perugia, the wealthiest, most powerful, and most independent of them all, mounted the greatest resistance. In the 16th century, the murderous Baglioni clan, the city's ruling family, went so far as to try to assassinate a papal legate. The papacy retaliated, first by increasing the salt tax (avoidance of this usurious yet frequently used form of taxation is why Umbrian bread has no salt) and eventually by taking over the city and, for good measure, levelling the Baglioni palaces and the surrounding neighbourhood. (As you ascend from the city's underground parking lots, a series of passageways takes you past these evocative ruins.)

Umbria did not embrace the Renaissance with the same fervour as its neighbour Tuscany, but there was certainly an artistic flowering here as well. You need only experience

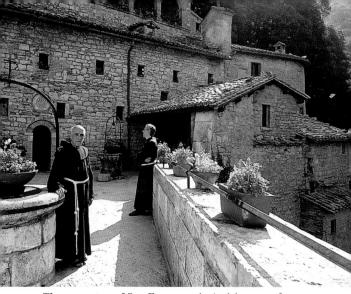

The monastery of San Francesco in Assisi—one of many tranquil pockets in this spiritual landscape.

Giotto's frescoes depicting the life of Saint Francis (in the church dedicated to the saint in Assisi) to appreciate the accomplishments of the painters who worked in Umbria.

Into the Present

For better or worse, the church maintained a stronghold on Umbria well into the 19th century. The benign neglect with which papal powers administered the region may well account for the fact that Umbrian hill towns have remained virtually unchanged over the centuries. Nor did unification with Italy bring prosperity to the region. In fact, it wasn't until the final decades of the 20th century that Umbria began to prosper.

WHERE TO GO

If all roads lead to Rome, for a traveller to Tuscany and Umbria an equal number lead to Florence. We begin our travels there; you may well do the same, or in any case find yourself drawn there not too long after you settle into the region.

FLORENCE

Florence has been variously described as the most beautiful city in Italy; a "city of stone". imposing and difficult to penetrate; the artistic and humanistic seat of the Renaissance; and one of the most popular tourist destinations in the world. It should come as no surprise, then, that its history is as varied as its current incarnations.

Florence was founded by Julius Caesar as a colony for old soldiers in 59 B.C., and traces of this orderly era remain in the neat layout of blocks between the Duomo and the Piazza della Signoria. The city muddled through the Roman era as a pleasant backwater, survived the Dark Ages intact, and then,

Before you venture too far, you should know that entrata is entrance, uscita is exit, tirare is pull, and springere is push. through the wars, revolutions, and religious turmoil of the next centuries, began to prosper. Under the generous patronage of the ruling Medici family, sculptors, painters, poets, and architects thrived. A surprising number of their works have

remained in Florence, kept there by a clause in the will of Anna Maria Ludovica, the last Medici, who in 1743 stipulated that none of the family's vast holdings were ever to leave Florence. Her wishes have largely been respected, and Flo-

The Duomo is a marvel of architecture and art, and still the site of religious services and processions.

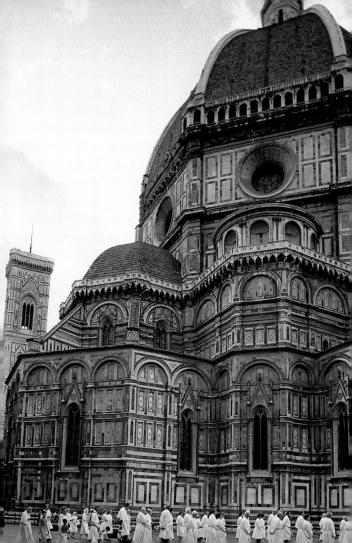

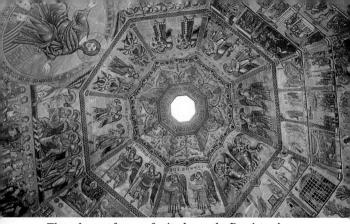

Though most famous for its doors, the Baptistery's brilliant mosaic-covered dome is equally breathtaking.

rence today provides the visitor an amazing concentration of the legacy of the remarkable minds of the Renaissance.

All this cultural heritage may sound a bit daunting, but take heart. Sights are close to each other, and all are just a few minutes walk from the Piazza del Duomo and its cathedral, the visual and geographic centre of the city.

The Duomo and Its Baptistery

The **Duomo** (more properly, Santa Maria del Fiore) was more than a century in the making. Begun at the end of the 13th century, it was not completed until the late 1460s, when the great central lantern, with gilded ball and cross cast by the painter and sculptor Verrocchio, was hung. The original plans were drawn up by Arnolfo di Cambio; he envisioned the largest cathedral in the world, with an octagonal crossing measuring nearly 150 feet across, to be topped by an enormous dome. Just eight years after construction began, Arnol-

fo died. A series of architects continued his work, completing the body of the church and the drum for the dome by 1418.

The architects faced a considerable structural challenge—how to erect a 300-foot-high dome over the vast crossing. Into the bickering community of architects and masons stepped fledgling architect Filippo Brunelleschi, who said he could build it, and without using expensive scaffolding, but declined to say exactly how. He was given the job, and confounded sceptics with the elegance of his solution. Brunelleschi designed the dome to be built in two shells of brick, arranged in cantilevered rings so that, as the structure rose, each layer of masonry would support the one above it. The Duomo remains today as one of the masterpieces of the Renaissance, floating above the city on the level of the surrounding hills, visible from every point, and providing fine views from every angle.

The exterior of the Duomo is clad in patterned marble of three hues—green, white, and red. To each side of the main façade is work dating from the cathedral's building, but the overly elaborate façade is actually a 19th-century construct. It is possible to walk right round the Duomo, and worth the effort. On the north façade is Porta della Mandorla; its relief, *The Assumption of the Virgin*, was executed by Nanni di Banco in the 15th century.

Inside is a large space, almost austere in its lineaments. The cathedral has accommodated 10,000 worshippers in its bare, gray-and-white interior, and one might imagine that they prayed largely undisturbed by artistic frivolities. Busts of Brunelleschi and Giotto are placed near the entrance. On the wall of the left aisle is a frescoed memorial to Sir John Hawkwood, the English mercenary who was a battle-winning captain of the Florentine army from 1377 until his death; it was painted by Paolo Uccello in the 15th century. Legend has it that Hawkwood was promised an equestrian

statue by his employers; his make-do memorial has a peculiar perspective, as if to suggest a statue.

Near the end of the aisle is a 15th-century painting by Domenico di Michelino, *Dante Explaining the Divine Comedy*, in which the Duomo is placed in clear opposition to Hell and Purgatory—a juxtaposition whose meaning must have been clear to a contemporary Florentine. In the right aisle are steps leading down to the old Santa Reperata church, around which the Duomo was built. In 1972 excavators found a funerary slab inscribed with Brunelleschi's name; it can now be seen through a gate.

The largest work of art in the Duomo is a fresco on the underside of the dome depicting the Last Judgment; the work was designed by the famous Florentine architect Giorgio Vasari, ex-

A term you might encounter when visiting museums and churches: *chiuso per restauro* (closed for restoration). ecuted by his student Frederico Zuccari in the late 16th century, and cleaned and restored in the late 20th

On the left aisle a door offers access to the top of the dome. The stairs and connecting walkways were designed by Brunelleschi with

exacting detail—there are iron hooks to facilitate cleaning and even spaces where canteens were installed for the builders. The gallery provides an excellent vantage point to view seven lovely, circular stained-glass windows by Uccello, Donatello, Ghiberti, and Castagno; the summit provides an extraordinary panorama of the city.

The Duomo tends to overshadow two other noteworthy buildings on the Piazza—the Campanile and the Baptistery. The Campanile is one of the loveliest belfries in Italy. Begun by Giotto in 1334 and finished after his death, it has been hard-hit by atmospheric pollution, and many of its sculptural reliefs are copies. The originals, including works

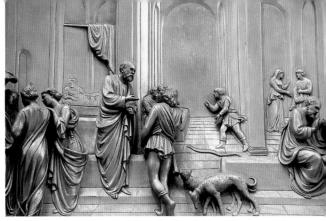

The Birth of Esau and Jacob—detail from The Gates of Paradise, on the Bapistery's original bronze east-wall doors.

by Donatello, are in the Museo dell'Opera del Duomo (see page 30). A terrace on top offers a view of the city.

The **Baptistery** dates to the sixth century, which makes it the oldest building in Florence. It may originally have been a temple to the Roman god of war, Mars; certainly it was once the city's main church and the site of a sort of mass baptism every March for all Florentine children born in the preceding year. The building is most famous for its bronze and gilded doors, the originals of which are also on view in the Opera del Duomo museum.

The doors on the south were cast in 1336 by Andrea Pisano, who succeeded Giotto in overseeing the Campanile; their 28 compartments depict the story of John the Baptist, patron saint of Florence (for the edification of his audience). Some 60 years after the doors were cast, the city organised a competition to choose a sculptor for the north door; it attracted a surfeit of talent, including Brunelleschi, Donatello, and

a 22-year-old Tuscan artist named Lorenzo Ghiberti. Ghiberti and Brunelleschi were deemed equally worthy by the judges, and it was suggested that they work together. However, Brunelleschi chose instead to study dome-making in Rome, and Ghiberti worked alone.

His achievement is considerable. The north doors show scenes from the lives of Christ, the evangelists, and the doctors of the church; one can see the sculptor's skill grow with each subsequent panel. Pleased with his work, the city commissioned Ghiberti to cast doors for the east wall; he began work on those in 1425. There, in his masterpiece, he altered his earlier conception somewhat, forming ten large panels to show scenes from the Old Testament. The art is vigorous and concise; the masterful low relief extends far into the background. Michelangelo, when he saw the work, called it the Gate of Paradise.

Inside, the Baptistery is stately, with its granite Roman columns and 13th-century mosaic ceiling and floors. The empty octagonal space in the centre was the site of the baptism of all of Florence's children.

Much of the art that once adorned the cathedral and the Baptistery is now housed in the **Museo dell'Opera del Duomo** on the northeastern side of the piazza. The glassed-in courtyard of the museum is where Michelangelo carved his David (1504) and where the original panels of the Paradise Gate of the Baptistery are now displayed, restored to their original gilded

Florence Markets

Mercato Centrale. Monday–Saturday 7am–2pm (Saturday also 4pm–7pm).

Mercato Nuovo (Straw Market). Daily 9am–8pm, Closes at 5pm and on Sunday and Monday in winter.

San Lorenzo street market. Daily 8am–8pm. Closed Sunday and Monday in winter.

glory. Other rooms on the ground floor contain statues intended for the unfinished cathedral facade. On the mezzanine is Michelangelo's second *Pieta*, partly finished by one of his students, and intended for the artist's own funerary monument. The first floor houses two *cantoria* (choir balconies) dating to the 15th century. One is by Donatello and one by Luca della Robbia; both are beautifully designed and executed.

The Bargello and the Piazza della Signoria

The Via del Proconsolo, just a few steps from the museum, runs toward the Arno river and the Museo Nazionale del Bargello, which contains an unmatched collection of Renaissance sculpture. Along the way the small Via Dante Alighieri turns right, to the **Casa di Dante**. This house may or may not have been Dante's birthplace; a small museum contains several editions of his *Divine Comedy*.

The Palazzo del Bargello is an imposing structure. Built in the mid-13th century, and for many years the seat of the magistrate of Florence, it was the site of numerous trials and public executions. The gallows hung in the courtyard, which was restored in the 19th century and is now a surprisingly elegant spot.

The great hall of the Museo Nazionale del

Frescoes from the school of Giotto cover the walls of the beautiful Bargello chapel.

In the shadow of greatness; a copy of "David" resides in the Piazza della Signoria.

Bargello contains works by Michelangelo and his school. He carved the classically inspired Bacchus when he was just 22 years old; his bust of Brutus was made after the murder of the brutally autocratic Duke Alessandro de Medici in 1537, and is a statement of his republican principles. A wide stairway leads up from the courtyard to the loggia, home today to a series of bronze birds cast by Giambologna for a Medici villa outside the city. The doorway to the right opens into a 14thcentury salon dominated by works by Donatello. Most notable are his bronze of David, and his figure of Saint George, carved in 1416.

In a rear corner of the Ghiberti and Brunelleschi

room are two bronze panels that Ghiberti and Brunelleschi entered in the competition to cast the doors of the Baptistery; the theme is the Sacrifice of Isaac. The remaining rooms on this floor contain a wide-ranging array of decorative art, including ivory carvings from Europe and the Middle East. On the second floor, the Sala dei Bronzetti holds a remarkable display of small bronzes dating to the Renaissance.

The Piazza della Signoria is just a few minutes' walk away, but detour first to the **Orsanmichele**, at the southern end of the Via dei Calzaiuoli. This is certainly one of the oddest

churches extant, perhaps not surprising when one realises that it was built to serve as a granary in 1337, then was turned into a chapel when an image of the Madonna inside became celebrated for performing miracles. The niches on the exterior are decorated with statues of saints commissioned by the city's merchant guilds; their deep pockets paid for the work of such first-rank artists as Ghiberti, Donatello, and Verrocchio. (Most of the originals have been replaced by casts.)

The expansive Piazza della Signoria is a great place to spend an hour taking in the bustle of Florentine life.

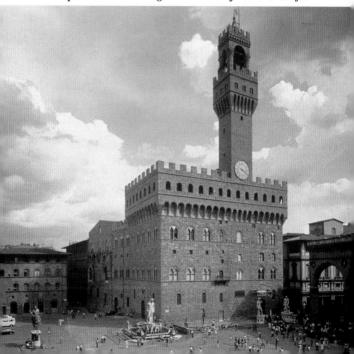

Florence Churches, Museums, and Other Sights

Casa di Dante. Wednesday-Monday 10am-6pm (4pm

in winter). €2.50.

Duomo. Mon-Fri 10am-5pm (to 3.30pm on Thurs); Sat10am-4.45pm (to 3.45pm first Sat of month); Sun 1.30-4.45pm. Free. Cupola: Mon-Fri 8.30am-7pm (to 5.40pm on Sat). €5.50. Baptistery: Mon-Sat noon-7pm, Sun 8.30am-2pm. €2.50.

Galleria degli Uffizi. Tues-Sun 8.15am-6.50pm.

€8.00.

Galleria dell'Accademia. Tues-Sun 8.15am-6.50pm. €6.50

Galleria Palatina. Daily 8.15am-6.50pm. €6.50

Giardini di Boboli. Daily 9am-sunset. €2.50; free under 18 and over 60.

Museo dell'Opera del Duomo. Mon-Sat

9.30am-6.30pm, Sun 8am-2pm. €5.00.

Museo Nazionale del Bargello. Tue-Sat 8:30am-1:50pm. Same hours 2nd and 4th Sundays and 1st, 3rd and 5th Mondays of the month. €4.

Orsanmichele. Daily 9am-noon and 4pm-6pm. Museum

9am-1:30pm. Free.

Palazzo Vecchio. Daily 9am-7pm (to 11pm on Mon and Fri, 15 June to 15 Sept; to 2pm Thurs and Sun). €5.50. San Lorenzo. Daily 7am-noon and 3:30pm-6:30pm. €2.50. Medici chapels: daily 8.45am-5pm (to 1.50pm on Sunday). €6.

San Marco. Tuesday-Saturday 8.15am-1:50pm (Saturdays to 6.50pm). Alternate Sundays and Mondays

8.15am-6:50pm. €4.

Santa Croce. Mon–Sat 9.30am–5.30pm (8am– 12:30pm and 3–5.30pm in winter). Sun 3–5.30pm. Free.

Santa Maria Novella. Daily 7am-11:30am and 3:30pm-6pm 9to 5pm on Sat and Sun). €2.50.

Inside is a masterful Gothic tabernacle designed by Andrea Orcagna in the mid-14th century.

One more detour takes you west from the Orsanmichele along Via Cimatori for one block to Via Calimala, which you can follow south for one block to the **Mercato Nuovo** (New Market, also known as the Straw Market), a lively centre of hucksterism where outdoor stalls are piled high with leather articles, painted trays, and other typically Florentine goods. Far more enticing than most of the merchandise is *Il Porcellino*, a bronze copy of a reclining boar (the original is in the Uffizi); even haughty Florentines will pause to rub the beast's well-worn snout, an act that is said to ensure good luck.

From here, follow Via Condotta one block east, turn right,

and find yourself in the expansive Piazza della Signoria, the historical centre of Florence and once the political centre as well. Savanorola, the Dominican friar whose fiery, puritanical oratory against worldly excesses gripped

Try asking per favore, parla lentamente (speak slowly, please) if you don't understand the response to a question.

Florence in the late 15th century, staged the Bonfire of the Vanities here, a huge conflagration of, well, vanities—fine clothes, art, and books. Savanorola was himself burned here, just a few years later.

Today the piazza is framed by beautiful statues, including a copy of Michelangelo's *David*. It also accommodates several cafés; enjoying a coffee or a *gelato* at one while admiring the surrounding monuments and observing little snatches of Florentine life is almost de rigueur for any visit to Florence. At the south end is the Loggia dei Lanzi, an airy dais built in the late 14th century.

The Palazzo Vecchio also fronts on the square. Originally designed by Arnolfo di Cambio, with additions made over

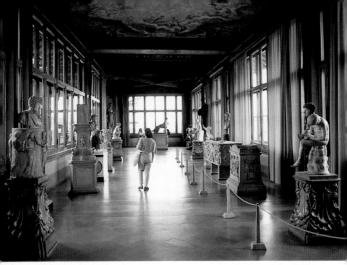

You could spend a week in the halls and galleries of the Uffizi Palace, the world's largest repository of Renaissance art.

the next few centuries, it serves as the seat of the municipal government. The building is inevitably described as "fortress-like" but actually contains some odd and lovely rooms that are open to the public. The huge Salone dei Cinquecento is panelled with 16th-century frescoes by Giorgio Vasari celebrating Cosimo de Medici's military triumphs; beyond the salon is a windowless chamber built for Cosimo's son, Francesco, and decorated to reflect his interest in alchemy. The lower row of paintings hides cupboards where Francesco hid his crystals and jewels.

Upstairs are several rooms of note—Eleanor of Toledo's chapel decorated by Bronzini in frescoes glazed with tempera, and the Sala dei Gigli, with a lovely 15th-century ceiling. The attached Cancelleria was once Niccolo Machiavelli's office;

the adjacent room is adorned with maps that show the known world circa 1563.

The Galleria degli Uffizi

A few steps away is the Uffizi (in full, the Galleria degli Uffizi), which contains an unrivalled collection of Renaissance art, with masterworks by Giotto, Uccello, Botticelli, da Vinci, Michelangelo, Raphael, Titian, Caravaggio, and others. One could easily spend a week here. While that probably is not possible, certain treasures are not to be missed in even the shortest visit. The Uffizi is the world's largest repository of Renaissance art, and a walk through its galleries provides a fine overview of the flowering of European culture. (Please note that some rooms may be closed, and some paintings shifted; the following, however, should give you the approximate location of major works. Keep in mind, too, that you may want to take a break from your tour and enjoy the view from the pleasant roof-terrace bar.)

In room 2 is the *Ognissanti Maesta*, the Madonna enthroned, painted by Giotto in 1310, and one of the first renderings of this subject to present it realistically. Room 3 contains the *Annunciation* by Simone Martini, with the Virgin regarding the angel from a field of gold. In the centre of room 7 is a diptych by Piero della Francesca depicting Frederico da Montefeltro, the Duke of Urbino, and his wife, painted in profile and gazing at each other still. Rooms 10 to 14, now one large hall, are devoted to Botticelli; note especially his *Birth of Venus*, in which the newly born goddess floats to shore on a shell. Room 15 contains early works by Leonardo da Vinci, including an *Annunciation* painted in 1472.

Succeeding rooms offer works by Albrecht Dürer and Bellini, among others. In room 25, the centrepiece is Michelangelo's *Tondo Doni (Holy Family)*—his only finished easel

painting. Room 28 is devoted to works by Titian, chief among them the *Venus of Urbino*, a fleshy and provocative nude. Rooms 31 to 35 display the works of artists from Italy's Veneto region, including Tintoretto's *Leda* and Paolo Veronese's *Annunciation*. Room 41 contains works by Rubens and Van Dyck; room 44 has several Rembrandt portraits, notably his haunting *Self-Portrait as an Old Man*. Finally, a door off the corridor between rooms 25 and 34 leads to the Corridorio Vasariano, which connects the Palazzo Vecchio to the Pitti Palace, across the Arno. If this passageway is open (often it is not), by all means take advantage of the opportunity. Windows provide views of the city, and the halls are lined with self-portraits by Raphael, Velasquez, and Ingres, among others.

Across the Ponte Vecchio to the Palazzo Pitti

The more traditional way across the river is by foot, on the **Ponte Vecchio**. It was built in 1345, at the site of an older wooden bridge, and is the only one of the city's bridges that wasn't mined by the German army during World War II. Its stalls are lined with shops, many offering jewellery. Via Guicciardini leads directly to the **Palazzo Pitti**, an immense structure begun in the middle of the 15th century on a design by Brunelleschi; the original Renaissance concept is now almost completely obscured by additions made over the next few centuries. The Pitti family were rivals in wealth and power to the Medicis; the palace was intended as a statement to that effect. As fate would have it, the Medicis eventually moved into the Pitti Palace themselves.

The palace and the adjoining Giardino di Boboli contain eight museums, most notably the **Galleria Palatina**, a series of ornately decorated apartments that house an excellent collection of High Renaissance art. In the Sala di Apollo are two works by Titian—his *Portrait of an Unknown Gentleman*

and a golden portrayal of Mary Magdalene. The Sala di Giove contains Raphael's La Velata, a serene portrait of his Roman mistress Raphael also fills the Sala di Saturno, particularly Madonna della Seggiola, a depiction rounded seems to curve off the canvas. Other museums in the complex include one devoted to modern art, and one to the decorative arts.

The Giardini di Boboli (Boboli Gardens), the city's only large, green space, have been open to the public since 1766. The gardens' paths traverse a steep hill, beautifully planted and with many shady corners. In an amphitheatre in the centre, the Medicis staged lavish entertainments that involved singing and dancing and

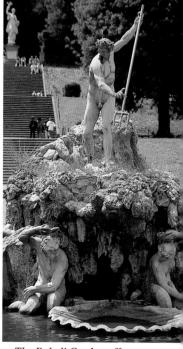

The Boboli Garden offers a chance for a pleasant stroll after exploring Palazzo Pitti.

were probably an early form of opera. The gardens are dotted with sculpture; note especially the Grotto del Buontalenti to the left of the entrance, a man-made cave complete with stalactites, stone animals, and copies of Michelangelo's famous statues *The Slaves*. The originals stood here until the early part of this century and are now in the Galleria dell' Accademia (see page 41). The Forte de Belvedere, at the

A fragmented fresco adorns a wall within the church of Santa Croce, where many famous Florentines are buried.

crest of the hill, provides a wonderful view of the city, with the Duomo floating above the skyline.

Santa Croce

Savour the vista from the Forte de Belvedere, then head back across the Arno. Before returning to the Duomo, you might wish to detour east to **Santa Croce**, the Franciscan outpost in the city, said to be founded by Saint Francis himself. The church was begun at the end of the 13th century and consecrated in the mid-15th; the façade was not completed until 1857.

Today the huge interior serves as the final resting place for many prominent Florentines, including Michelangelo (first tomb on the right aisle, designed by Vasari), Dante Alighieri (monument only, as his bones are in Ravenna), and Galileo (on the opposite side of the church). The frescoes in the Cappella Peruzzi and the Cappella Bardi, on the right side of the church, are by Giotto. They are in poor condition, partly because Giotto painted onto dry plaster instead of wet, and partly because of later vandalism—in the 18th century, they were actually whitewashed over, then were retouched in the 19th. Nonetheless, Giotto's depictions of scenes from the lives of Saint John the Evangelist, Saint John the Baptist, and Saint Francis are infused with his vigor and humanity; above the entrance to the Bardi chapel is the powerful Saint Francis Receiving the Stigmata. Note also the wooden crucifix by Donatello in the chapel at the end of the left transept, criticised by Brunelleschi for making Christ look like a mere peasant, but peculiarly resonant to modern eyes.

The Accademia to Santa Maria Novella

Back at the Duomo, Via Ricasoli runs directly to the **Galleria dell' Accademia**, a fine painting gallery that contains several transcendent

In a church, it is disrespectful to wear shorts, short skirts, or clothing that exposes your back and shoulders.

sculptures by Michelangelo, including his *David*. Michelangelo completed the statue at age 29, and it originally stood outside the Palazzo Vecchio; it was moved to the Accademia in 1873. Designed as a public monument, it tends to dwarf its space here, but remains one of the most popular sights in the city. The hall leading to *David* contains *The Slaves*, which Michelangelo began some 20 years later. The figures appear to be unfinished, and the artist's intent is a subject of debate among art historians. Whatever the case, this work seems to typify Michelangelo's belief that sculpture is an "art that takes away superfluous material".

A few steps farther up Via Ricasoli are the **church and monastery of San Marco**. A monastery has stood here since

medieval times; in 1437, it was converted into a Dominican retreat by Cosimo de Medici, and soon became the site of the first public library in Europe. One of the early friars was the artist Fra Angelico, and the monastery was also the home of the puritanical preacher Savonarola, who was prior here before he was burned at the stake in 1498. The museum, entered off a cloister, has many of Fra Angelico's devotional images, painted with loving detail. His masterpieces, however, reside in the Dormitory above, where the monks lived; these include the *Annunciation*, at the top of the stairs, and paintings in the various rooms, designed to inspire the monks in their contemplations.

A short jog back toward the Duomo is San Lorenzo, the oldest church in Florence, and the Medici's local parish. Their patronage funded a rebuilding of the original fourth-century structure in the 15th century, designed by Brunelleschi. His skill is evident in the Old Sacristy, a lovely bit of Renaissance architecture, decorated with terra-cotta designed by Donatello. The Medici chapel, entered behind the church, contains a gloomy and ornate collection of Medici tombs. The highlight is the New Sacristy, designed by Michelangelo in 1520; note especially his carved tombs for Lorenzo, Duke of Urbino, and Giuliano, Duke of Nemours.

Very much a part of the here and now is the **San Lorenzo street market** on the piazza out front, where, with a sharp eye and strength to fend off aggressive sales pitches, you may be able to find some excellent leather goods and clothing. Just north of the church is a more interesting commercial enterprise, the **Mercato Centrale**, the city's major food market.

Just a few blocks west of San Lorenzo, toward the train station, is **Santa Maria Novella**, a Dominican church with an oddly cheerful green, white, and pink patterned marble façade. The interior of this 14th-century church contains some lovely frescoed chapels; note especially the sanctuary behind

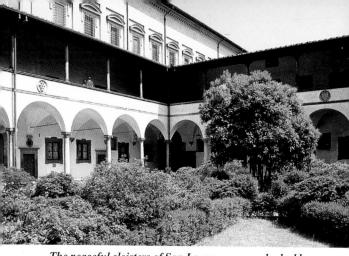

The peaceful cloisters of San Lorenzo are overlooked by the Laurentian Library.

the main altar, created by Ghirlandaio and his assistants, including a young Michelangelo. The adjoining museum, situated in the cloisters, displays frescoes by Paolo Uccello. His depiction of the Biblical flood was damaged by the 1966 floods, but his mastery of perspective can still be appreciated.

AROUND FLORENCE

While Florence itself can be all-consuming, several spots nearby provide delightful day trips, and perhaps a different view of the city itself.

Fiesole

Fiesole, perched on the hills to the northeast 8 km (5 miles) from Florence, is one such town. (Take the #7 ATAF bus from the Santa Maria Novella station.) Originally settled by the

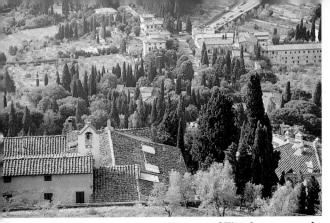

The lush hillsides around the town of Fiesole are covered with cypress trees and country villas.

Etruscans, the municipality waged an uneasy battle with its larger, richer neighbour for centuries—until 1125, when the Florentines attacked and levelled it, piously preserving only the cathedral and the bishop's palace. Since then, Fiesole has been a retreat for the wealthy from the city's summer heat and humidity, a heritage that shows today in its many beautifully kept villas, surrounded by extensive gardens.

Fiesole's centre is the Piazza Mino, a fine spot for an iced drink on a hot day; from it you can admire the Duomo and its graceful campanile. Via Marini, off the piazza, leads to a Roman theatre and Etruscan tombs. The 3,000-seat theatre was built in the first century and excavated at the end of the 19th; it is well-preserved and still used for performances. Three arches nearby mark the site of the Roman baths; from here, it's possible to view a stretch of the original Etruscan city walls. Signs to the east of the theatre point up a hill to three Etruscan tombs dating to the third century B.C. You might wish to walk back to

Florence on the signposted old Fiesole road; if so, stop on the way to admire the gardens of the Villa Medici or the Villa Le Balze, both of which are open to the public.

Prato

Prato, 17 km (10 miles) to the northwest of Florence (reached via train or bus from Florence; by car, take the A11) is the Italian word for meadow, and while this fast-growing industrial city is a far cry from a flower-filled field, it is a lively spot with several sites of interest.

Since the Middle Ages, Prato has been a textile centre, and it still produces the major share of Italian woollens. This history of prosperity has left a wealth of art. The 15th-century **Duomo**, in the central piazza, is fronted by an Andrea della Robbia terra-cotta over the portal, and *The Pulpit of the Sacred Girdle*, with friezes by Donatello (originals now in the museum), on the southwest corner. Here, five times a year, the Virgin Mary's girdle (a woollen belt) is displayed; legend has it that the girdle was given to Saint Thomas by the Virgin moments before she was assumed into heaven. After passing through several hands, the relic ended up in Prato.

Inside the Duomo, frescoes by Filippo Lippi surround the altar. They depict the lives of John the Baptist and Saint Stephen in a playful and mesmerising manner. The adjoining museum houses Donatello's original panels from the great pulpit, somewhat the worse for wear from exposure to exhaust fumes. A few blocks from the Duomo is the Castello dell'Imperatore. Built in 1237 by Frederick II, the castle is largely empty today but provides a lovely view from its ramparts.

The Medici built many country houses around Florence. At first, they were fortified hideouts, but in more peaceful times they became luxurious second (or third) homes. The Villa Medici di Poggio a Caiano, in the northern outskirts of Prato,

18 km (11 miles) to the northwest of Florence (reached via bus from central Prato or from Florence), is one of the earliest and most typical. Lorenzo the Magnificent bought a farmhouse on the site in 1480, then had it rebuilt in the Renaissance mode. It is raised on a podium; the entrance is actually through the basement, which is furnished with game rooms and a private theatre. Upstairs is a huge salon, decorated with lovely frescoes, and the gardens are a pleasant place to stroll.

Pistoia

Pistoia, 35 km (21 miles) northwest of Florence and 18 km (11 miles) northwest of Prato (it can be reached from either city by train or bus; by car, take the A11 or S435), has a medieval centre with narrow alleys. Pistoia was the seat of battles that

The Maria Mater Gratiai, a quaint corner chapel in the industrial city of Pistoia.

plagued Tuscany in the 13th century and, appropriately, its name is the origin of the word "pistol". Today it is a busy industrial city, and the site of lovely Romanesque churches. The Duomo, in the central piazza, was built in the 13th century and boasts the remarkable Altar of Saint James, a construction of gilded silver decorated with medieval saints and scenes from the Bible. Two prophets carved by Brunelleschi stand on the right. Visit also the Ospedale del Ceppo, a hospital founded in the 13th century and still in use. The terra-cottas on the façade illustrate the cardinal and theological virtues, as depicted by Giovanni della Robbia (son of Andrea).

Montecatini

Just west of Pistoia is Valdinievole, or the Valley of the Mists, where spas are fed by underground springs and where centuries of Florentines have sought a cure for the excesses of city life. The best known among them is Montecatini Terme, 46 km (28 miles) west of Florence and just 12 km (7 miles) west of Pistoia (easily reached via train from either, or by car via the A11 or N435). Here

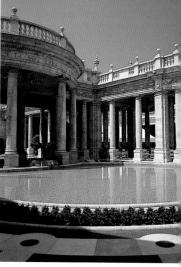

Montecatini Terme, where many come to luxuriate in mineral-rich waters.

the waters are sulfurous and the shopping luxurious. The centre of town is the **Parco dei Termi**, where a row of spas housed in Neo-Classical temples are perched over their various springs. Most are open for mud wraps, mineral elixirs, and relaxation from May until October; the Excelsior is open year-round.

Siena and Chianti Country

The lovely swath of land stretching due south from Florence to Siena is Chianti country, an area of clustered peaks surrounded by rolling hills and crossed by a multitude of streams. Grapes have been planted and fermented in this temperate, rural region for thousands of years, and despite recent

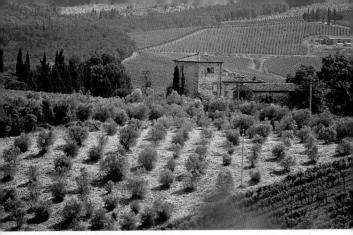

Vineyards interspersed with olive groves are the hallmarks of fertile Chianti country.

immigration by more northerly Europeans who summer and retire here, it has maintained a sense of peace and purpose.

Although most major towns are served by train and/or bus from Florence and Siena (the cities are 70 km/43 miles apart), the best way to appreciate Chianti is by car. Although you can speed through the region in about half an hour on a modern motorway that links the two towns, the best route to take is the S222, the **Chiantigiana**, which winds through the heart of the region in leisurely fashion and links to the myriad of tiny roads that serve it.

It can be difficult to find the start of the S222, but you really don't want to settle for one of the alternate, less attractive routes to Siena; from central Florence, look for the Firenze Certosa or Firenze Sud entrances to the A1 autostrada, which speeds south to Rome; the Chiantigiana and the first village you come to on the road, Grassina, are well-signposted from

either. You'll need a good map and a sense of adventure because, while many of the loveliest towns and most famous vineyards are near the main highway, the most rewarding stops are those you will discover yourself.

Arguably the best-recognised wine in the world, Chianti was, in effect, created by the Grand Duke Cosimo de Medici III in 1716 when he declared that only certain parts of Tuscany could call their wine Chianti.

Drive slowly south to **Greve**, 45 km (28 miles) from Florence, the centre of the wine trade and the host each September of the region's largest wine fair. Greve started as a market town in the 13th or 14th century, and has slowly grown to become Chianti's unofficial capital. Its charming

central Piazza Matteotti is lined with a patchwork of arcades, each built by a different wine grower. The statue in the centre of the square is of Giovanni Verrazano, the European discoverer of New York Harbour, who was

Super rapido and rapido trains stop only at major cities. Espresso and diretto trains stop at large stations. Locale trains make all stops.

born nearby. You'll note that there is a wine shop on nearly every corner, many offering tastings, and all offering varieties unavailable anywhere else. Greve's castle burned down in the 14th century, and its convent has long since been converted to a prison. But just a kilometer (about half a mile) to the west is the castle of **Montefioralle**, a well-restored fortification with octagonal walls and two fine Romanesque churches. It provides an image of the region as it once was.

Radda, some 10 km (6 miles) south of Greve, has a lovely and well-preserved historic centre, and is an appealing spot for a stroll. On the way, you might wish to make a short detour to the **Castello di Volpaia**, one of the region's wine estates. Most of the large medieval castle is gone, but the

central keep still stands; tastings and sales are held during the summer months. The surrounding village, medieval in tone, contains a pretty Renaissance church. Just east of Radda is the Badia a Coltibuono, an abbey first founded in 770, now an agricultural estate that produces a fine red wine.

Siena

Just as Florence is the city of the Renaissance, Siena belongs to the Middle Ages. Where Florence's greatest attractions are in its museums, Siena's are in its squares and streets, perched on three hills that provide views from many vantage points. To see both Florence and Siena is to appreciate each even more, and no visit to Tuscany should omit either.

Siena was founded by the Etruscans and colonised by the Romans. During its heyday in the 13th and 14th centuries, it was a flourishing centre of trade, banking, and art. In May 1348, however, the Black Death (or Plague) reached Siena, winnowing the population and dealing a blow from which the municipality would never quite recover. Before the epidemic hit, Siena had some 100,000 citizens; when the disease had run its course, only 30,000 remained. Regional wars and intrigue followed, until a siege by the Medicis in the 16th century devastated the city, turning it into an insignificant part of the Florentine empire. Those events have, in a sense, frozen Siena in historic time, and the city remains very much as it was in the 14th century.

Il Campo

This large piazza, the heart of the city, is placed at the intersection of the three ridges upon which Siena sprawls; laid

The Gothic Palazzo Pubblico, with its 102-m (335-ft) Torre del Mangia from which there are spectacular views of the city.

The Duomo and Nearby Museums

Siena's Duomo, a few minutes walk south of Il Campo, is, in a sense, another victim of the Black Death; while it was initially completed in 1215, a new nave was started in the 14th century but was abandoned when the Plague struck. It still stands, unfinished. The original structure, however, is lovely. The façade, designed by Giovanni Pisano, is boldly patterned in black and white marble, and this pattern is repeated in the interior's pavement, which also contains dozens of inlaid panels created by local artists. The central panels are uncovered only in August, during the Palio (see page 54). The pulpit at the left aisle, by Nicola Pisano, is carved with panels depicting the life of Christ; supporting columns rest on stone lions.

The Museo dell Opera Metropolitana, housed in the Duomo's unfinished nave, contains most of the original façade statuary, as well as a magnificent altarpiece by Duccio. Painted in the early 14th century, it is a majestic example of late medieval art, and the central figure of the Virgin is a study in serenity. The Treasury Room upstairs contains a gilded silver reliquary; the highest staircase leads to the walkway above the facade and provides a wonderful view.

Just a bit farther south is Siena's painting gallery, the **Pinacoteca Nazionale**, housed in a 14th-century palace. The works on display are primarily arranged chronologically, from the 12th century to the Renaissance, and the museum is compact enough to afford a view of the development of Sienese painting styles. The ground floor contains some Renaissance works; on the second floor, paintings from Siena begin. Note especially Guido da Siena's *Scenes from the Life of Christ*, one of the first known paintings on canvas; Simone Martini's *Madonna and Child*; and Beccafumi's cartoons for the floor panels in the Duomo.

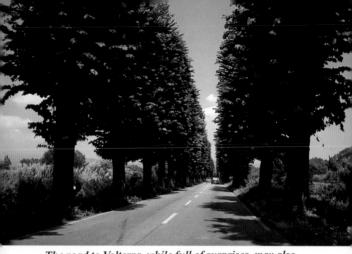

The road to Volterra, while full of surprises, may also induce a feeling of déjà vu.

On 2 July and 16 August each year, your serene contemplation of the Gothic in Siena will be cheerfully and noisily disturbed by the Palio, a more or less free-for-all horse race around the Campo. The Palio has its roots in the old *contrada* system of the city, whereby Siena was divided into *contrade*, or neighbourhood wards, which served as small political units, each with its own governing body, social club, and local parish. The number of contrade was fixed at 17 in 1675; of these, ten sponsor horses that run in the two annual Palio races. The theory of the race is based on chance—the contrade draw their horse and starting position by lot.

The race consists of three laps around the Campo on a sanded and well-padded course. The winner is the horse, mounted or not, that completes the circuit first. The single

rule of the race is that jockeys may not interfere with each others' reins. Needless to say, mayhem reigns. As this race stirs enormous passions, seats are impossible to come by unless you book well in advance. Your best bet is to appear at the square well before starting time and mark out your spot. It's well worth the trouble, because this is one of the most genuine incarnations of ancient Siena, and a great deal of fun as well.

The Classic Hill Towns —On the Road to Volterra

A number of surprisingly pastoral hill towns are perched to the north and west of Siena. They are an easy and scenic drive from the city; public buses from Siena will also take you there. As you travel through the region, you may well be overcome by the feeling that you've experienced this landscape before.

You have, in a sense, because the rolling hills—a reddish-brown colour (known appropriately as burnt siena) in places where the soil has been tilled, forested in part with cypress and pine, and often crowned by medieval cities-form the background of many Renaissance paintings.

Handy road terms: a oneway street is a senso unico: speed limit is limite di velocità.

The best way to explore these cities is to immerse yourself in the Tuscan countryside by making the scenic drive through Chianti country on route S222 to Siena (see page 48), then approaching them from that lovely city. If, however, you are making the trip directly from Florence, you can bypass Siena by taking the speedy S2 south to Monteriggioni, a trip of 55 km (33 miles), and begin your explorations there.

Monteriggioni, 15 km (9 miles) northwest of Siena on route S2, once provided the Sienese with a lookout point for Florentine troops, and its 14 towers and fortified walls still stand, perhaps the best preserved in Italy. They protect a tiny

town within that is not much larger than a soccer pitch. Construction on this bastion started in the early 13th century, and, girded by stone as it is, the village hasn't grown much since. Dante likened the towers to a circle of Titans guarding the lowest level of hell, and his verse, from the Inferno, faces you as you enter Monteriggioni. There are some houses and a few restaurants inside the walls, and not much to do except soak up the charm of the place.

Colle di Val d'Elsa, about 10 km (6 miles) farther along on the S68 (simply follow the road signs, which often do not indicate route numbers), must be approached from the correct angle. The lower town, which you will see first if you enter from the east, consists of unlovely housing tracts and factories; enter from the west, however, and you will pass under a 16th-century gate into the old town. Via del Castello, the main street, stretches along a ridge, and is lined with medieval houses. Arnolfo di Cambio, architect of Florence's Duomo, was born at number 63. The street leads on to the Piazza del Duomo and the cathedral. Originally a Romanesque structure, the cathedral was rebuilt in the 17th and 18th centuries. Inside, however, is a fine marble 15th-century pulpit, a lovely Nativity by Rutilio Manetti, and, commanding pride of place, the Cappella del Santo Chiodo, which contains a nail from the True Cross. The small Museo d'Arte Sacra, also on the square, houses some interesting frescoes and a collection of Sienese painting. Just off the piazza is the 16th-century Palazzo Campana, a mannerist-style mansion.

San Gimignano

This town of towers 11 km (7 miles) north of Colle di Val d'Elsa presents a stunning skyline, with its tall and beautifully preserved medieval towers. Inside the walls, the town's lovely streets and churches, its medieval and rural atmos-

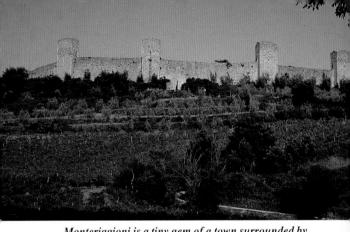

Monteriggioni is a tiny gem of a town surrounded by 13th-century fortified walls and towers.

phere, and its fine collections of art have made it a popular destination for tourists—too popular, perhaps. In season, it fills with day-trippers, and its chief industry seems to be the selling of postcards. But out of season, or in the evenings, the town provides all that its other-worldly beauty promises.

Founded by the Etruscans, San Gimignano was named in the fifth century to honor a bishop of Modena who reputedly saved the village from Attila the Hun. It prospered during the Middle Ages, then was struck hard by the Black Death, and entered the modern era as a desperately poor backwater. Tourism has changed all that, and the town now prospers because of its beauty and a fine local white wine called Vernaccia. At its heart is the Piazza del Duomo and the Collegiata, the town's largest church. The foundations of the church were laid in the 11th century; much of what you see now was constructed in the 15th. The interior is grandly decorated with frescoes. Note especially the New Testament scenes on

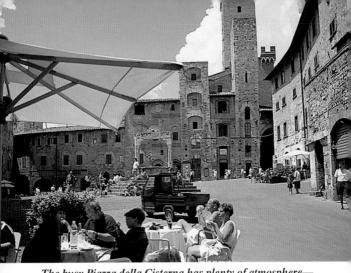

The busy Piazza della Cisterna has plenty of atmosphere—soak it up in one of the sidewalk cafés.

the right wall painted by Lippo Memmi in the 14th century. The Cappella di Santa Fina, off the right aisle, was built in the 15th century by Giuliano de Maiano. The frescoes, by Domenico Ghirlandaio, depict the life of Santa Fina, a local girl who attained sainthood status for her piety. The Torre Grossa, also on the piazza, is the tallest of the town's towers at 54m (175ft); it dates to the early 14th century, and provides an extraordinary view of the surrounding Tuscan countryside.

The adjacent **Piazza della Cisterna** is ringed by cafés, restaurants and *gelaterie*.

Volterra

Some 37 km (23 miles) west on a lovely drive through undulating farm country interspersed now and then with vineyards,

orchards, and little copses (from San Gimignano, drop south to route S68) is Volterra, a lofty town stretched along a high ridge and home to a wonderful collection of Etruscan art. The ancient city, in the centre of a rich mining region, was much larger than what remains today; settled first by the Etruscans, then, centuries later, taken by the Florentines in a bloody siege, it is now a quiet and somewhat mysterious place.

Volterra's heart is the Piazza dei Priori, which is almost entirely bounded by medieval buildings. The 13th-century Palazzo dei Priori probably served as the model for Florence's Palazzo Vecchio, and its tower provides an excellent view. The Palazzo Vescovile, or Bishop's Palace, also on the piazza, houses a small museum containing a bust of Saint Linus by Andrea della Robbia. The Duomo, built in the 12th century, is just off the square; it has a wonderful ceiling, carved and decorated with gold and azure. Note also the *Crucifixion*, painted by Francesco Curradi in 1611 and a fine example of Baroque work. The Pinacoteca e Museo Civico, also off the piazza, has some fine pieces by local artists, notably Rosso Fiorentino's *Descent from the Cross*.

Traces of the Etruscans

But the real reason to come to Volterra is to see what the Etruscans left. The **Museo Guarnacci**, on Via Don Minzoni, houses a large collection of Etruscan artifacts, most found in the area (open daily, 9am to 7pm in summer, 9am to 2pm in winter; admission fee). Most notable are its funerary urns, a few of which date to the ninth century B.C. The urns, in the form of rectangular boxes, are carved with striking depictions of the deceased occupants; many show touching farewells, and together the 600 or so urns provide a fascinating picture of Etruscan beliefs about death and, by extension, life. Note

especially the *Gli Sposi* (the "Married Couple"), a first-century B.C. urn decorated with the faces of an elderly couple, as penetrating and passionate-looking now as they must have been in life, some 2,000 years ago. The museum also contains some bronzes; note especially the *Ombra della Serra* (the "Shadow of the Night"), a delicate and elongated nude.

The Balze, as Volterra's eroded cliffs are called, are a short walk northwest of the piazza along Via di San Lino. Here time and the weather are eating away the edge of the city, and the walls are literally dropping into chasms. Ancient alabaster mines gouge into the cliffs; below them are

When driving into a medieval town, the first thing you'll want to do is find the parcheggio (parking).

huge buried tracts of the original Etruscan settlement.

PISA AND THE COAST

The Tuscan Coast is a land apart from the rest of the province, sep-

arated from the valleys of central Tuscany by a coastal ridge of the Apennines and so different in appearance you won't associate it with any of the familiar images of vineyard-clad hills and undulating valleys. Here the landscape is flat, even marshy in parts, and often punctuated with oil refineries, cranes, bustling ports, and other accessories of the business of modern life. This is not to say there are not places that reward your journey to this part of Tuscany. Pisa is here, as is the lesser-known but more beautiful and interesting Lucca. Livorno is a fine place to explore a working port city, enjoy a seafood meal, and ship out for the island of Elba.

Lucca

This graceful and prosperous provincial capital, 77 km (47 miles) west of Florence on the A11, is encased by peculiarly elegant 16th-century walls—protective as well as deco-

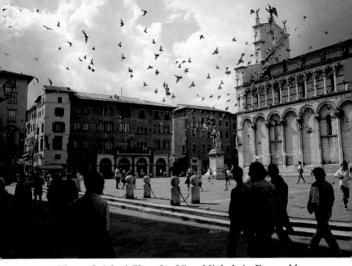

The unfinished Church of San Michele in Foro adds a touch of magic to charming, tranquil Lucca.

rative. The city is less visited than some surrounding spots, yet has a considerable charm, along with some famous musical sons, Boccherini and Puccini among them. To get a sense of the city, take a stroll or a bicycle ride along the tops of the walls, which are planted with plane trees and provide a lovely view; note the grid layout of the streets, a remnant of the city's Roman past. You might also note a paucity of cars. More than other Italians, Luccans tend to ride bicycles, and this makes the city a bit more pedestrian-friendly than most in Italy.

The Cattedrale di San Martino, on the piazza of the same name, has an asymmetric façade of green and white marble decorated with a striking assortment of little columns. Note the pillar next to the tower; it is carved with a 12th-century

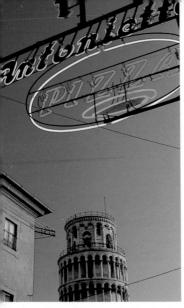

Pizza, Pisa: two Italian institutions share airspace in the town best known for its tower.

labyrinth, a symbol of how hard it is to get to Heaven. Under it are 13th-century stone reliefs; the sculptures around the doors are by Nicolo Pisano and others. Inside, in the sacristy, is the moving tomb of Ilaria Carretto Guinigi. Made by Jacopo della Quercia in the 15th century, it commemorates the young wife of a rich Luccan, memorialising her beauty. The octagonal Tempietto (Little Temple) by Matteo Civitali was built to house the Volto Santo, a wooden statue of Jesus crucified that is said to have been carved by Nicodemus. The museum across the street from the cathedral contains the gold and jewel-encrusted orna-

ments used to dress the Volto Santo on special holidays.

A few blocks away, on the Piazza San Michele, is San Michele in Foro, a 12th-century Romanesque church with a lovely façade. The body of the church is unfinished, and so the façade, with its rows of columns, each different from the other, towers above it with the upper levels fronting pure air. The effect is magical. Inside, in the right nave, is an ornately painted organ and a painting by Filippino Lippi of various saints. Opera lovers may wish to visit the church of Paolino, just two blocks to the west. Puccini worked here as an organist.

Pisa

The university town of Pisa, some 25 km (16 miles) southwest of Lucca, was a maritime power in the 11th century and certainly one of the largest and most cosmopolitan cities in Europe; its lovely centre is a testament to those days. From Lucca, take route S12 or the A11 and A12 autostradas to Pisa; there is also frequent bus and train service between Lucca and Pisa. If you plan to make a day trip to Pisa directly from Florence (the distance is 77 km/47 miles), take the A11 and A12 autostradas.

By the 14th century, Pisa's harbour had silted over, and the city, like much of Tuscany, fell under the hegemony of the Florentines. Over the centuries, Pisa's most notable achievements have been intellectual—it is the seat of a university, home to Galileo, and, in more modern times, the physicist Enrico Fermi. Thousands of tourists flock here, however, to see one landmark—the Leaning Tower, located, together with the baptistery and the duomo, on one of the loveliest squares in the world, the wide grassy expanse of the Campo dei Miracoli.

Thanks to its unstable subsoil, the Leaning Tower (Campanile) has always tilted. Begun in 1173, it began to lean when only three of its eight stories had been completed. The overhang increased over time, and by the late 20th century it was 4.5m (15ft) out of alignment. Fearing an imminent collapse, the authorities closed the tower in 1990 while engineers sought a remedy. It was finally decided that soil should be extracted from the foundations on the opposite side to the lean, and by early 2001 the top of the tower had been brought back 45cm — a 10% reduction in inclination. The tower is now open to the public once more, with 30 people allowed up the 293 steps at a time (guided tours every 40 minutes).

The 12th-century tower isn't the only crooked building on the square; the **Baptistery**, its contemporary, tilts slightly to the north. The largest in Italy, the Baptistery's lower parts are

Romanesque, while its upper levels are decorated in the Gothic style by sculptors Nicola and Giovanni Pisano; the originals are now in the Museo dell'Opera del Duomo (see page 65). The interior is strikingly bare, with fine acoustics. Nicola Pisano carved the 13th-century pulpit, and his work deliberately includes Classical elements; the figure of Daniel, for example, bears a striking resemblance to the Greek hero Hercules.

The **Duomo**, started in the 11th century, is a lovely example of Pisan Romanesque, with its colonnaded exterior subtly patterned in grey and white stone. The Portale di San Ranieri, an original bronze doorway, is still in place. Cast by Bonnano Pisano in the 12th century, it shows scenes from the life of Christ. The interior, remodeled after a 16th-century fire, is mostly Renaissance. A fine pulpit by Giovanni Pisano sur-

Still a working port city, Livorno has been a popular stop on the trade route since Roman times.

vived the fire, however, and the figures on its densely carved surface seem to be rising freely from the base. Note the bronze lamp near the pulpit—legend has it that Galileo devised his laws regarding the movement of pendulums while watching it (or a predecessor) swing during mass one morning.

The 13th century **Camposanto cemetery**, at the north end of the Campo dei Miracoli, was built to hold the soil a local archbishop carried back from Golgotha, so that Pisans might be buried in holy earth. It has an unearthly beauty today, constructed in the shape of a huge cloister, with tombs of many styles and ages lining its arcades. The walls were once covered by magnificent frescoed paintings; however, bombs dropped by Allied planes in 1944 destroyed most of them.

The Museo dell'Opera del Duomo contains many statues and other works of art from the Duomo and the Baptistery. Note especially a Madonna by Giovanni Pisano, carved on an ivory tusk, and 19th-century etchings by an art restorer of the now-destroyed Camposanto frescoes.

Livorno

The busy port city of Livorno (known to most English speakers as Leghorn), 19 km (12 miles) south of Pisa on N1 or A12, has an appealing, working-class aura and, for the sightweary traveller, a refreshing lack of famous churches. It is chiefly known for two things: the sculptor and painter Amadeo Modigliani was born here in 1884, and the city's seafood restaurants are among the best in Italy.

Originally a Roman port, Livorno reached prominence when Pisa's harbour began to fill with silt. Under the Medici it became a free port, and a group of refugees including Jews, Greeks, Muslims, and Roman Catholics from England took up residence here, making it one of the most cosmopolitan cities of the Renaissance. In World War II, it was heavily

bombed; since then, it has thrived in the unlovely container shipping trade.

The original port, as designed under the Medici, included a series of canals that have inspired some to call Livorno a little Venice. The city merits a short exploration before lunch or dinner; the best place to see the original plan is the **Porto Mediceo** on the water. The **Duomo** in the Piazza Grande here has a doorway designed by Inigo Jones, who based his plan for London's Covent Garden on this square.

Massa Marittima

In spirit and appearance, Massa Marittima, 75 km (47 miles) southeast of Livorno on N1, is closer to the Sienese hill towns. It belongs, however, firmly to coastal Tuscany, situated as it is just above the seaside plain called the Maremma, a flat

When asking directions, the reply may well contain the terms destro (right) and sinistra (left).

marshy landscape at the base of the mountains that separate this part of Tuscany from the hillier terrain to the east. Originally a marshy expanse, the Maremma was drained and cultivated by the Etruscans

and their successors, the Romans. In medieval times, the land reverted to its original state, and it wasn't until the 1930s that the area was entirely reclaimed from malaria-carrying mosquitoes. Massa, named by the Romans to mean large country estate, is the chief town of the region.

The Piazza Garibaldi is the central square of the old town, and the Duomo fronts onto it. Constructed largely in the 14th century, it is a fine example of the Romanesque style. The Gothic campanile was added in the 15th century. Inside, to the left of the main door, are a series of medieval reliefs that provide a striking picture of the Massacre of the Innocents. The pride of the church, however, is the Arc of St. Cerbone in the

The Stella Fort crowns irresistible Elba, one of Italy's largest (and most frequently visited) islands.

apse. Saint Cerbone established a bishopric here in the ninth century, and the marble urn holding his remains is carved with reliefs depicting his adventurous and pious life, including his persuading a flock of geese to follow him to Rome.

Elba

It's impossible, when in Tuscany, not to think of the best-known Napoleonic palindrome in the English language—able was I ere I saw Elba—and it's equally difficult to resist the place itself. One of Italy's largest islands, Elba, which can be reached by ferry from Livorno, Piombino, and other Tuscan ports, has fine beaches, clear water for swimming, and mountains ideal for hiking. None of this is current news, however, and it's best to visit off season.

The chief town, Portoferraio, has a charming old section fortified under the Medici; enter it through the Porta al Mare. In the upper section is Villa dei Mulini, where Napoleon lived during his nine-month exile here. His second home, Villa San Martino, is a short drive south of Portoferraio.

A good network of roads traverses the island, and while most spots are served by local buses, mopeds are available for rent and probably provide the best means of exploring. While there are fine beaches everywhere, some of the best are on the south coast, especially at Marina di Campo. Rio nell'Elba, in the eastern part of the island, is the former mining centre; there's a museum of mining at its port, Rio Marina, with a display of local minerals. The town of Poggio, in the west, is in a lush area and serves as a starting point for some lovely hikes.

Arezzo and the Valdichiana

At the centre of Tuscany is a long and fertile valley, the Valdichiana. Medieval cities clustered on the hillsides flank the valley on either side. In this part of Tuscany, vineyards give way to olive groves and fields of sunflowers, and among the mainstays of the local economy are cattle, the source of the much-praised Florentine beefsteak (bistecca alla Fiorentina).

Arezzo

The A1 autostrada connects Florence and Arrezzo, 85 km (51 miles) apart, as does the slower but more scenic N70 (also known as the Strada dei Sette Ponti, because the road crosses seven bridges as it winds its way through olive groves and ancient towns).

Arezzo's old centre, girded by well-planned and attractive modern districts, bespeaks the great artistic talent that has flourished here. **Piazza Grande** is arcaded on one side by a loggia designed by Giorgio Vasari, the 16th-century architect who, enchanting as this assemblage is, will forever be better remembered for his accounts of masters more talented than he was, his *Lives of the Artists*—in effect, the first work of art history. Behind the unprepossessing brick façade of the 14th-century **San Francesco basilica**, just south of the piazza, is a

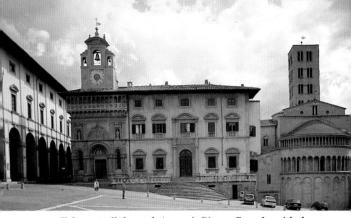

Take a stroll through Arezzo's Piazza Grande, with the bell-tower of the Pieve di Santa Maria in the background.

genuinely sublime series of frescoes by Piero della Francesca on the Legend of the True Cross. Painted in the 1450s, they show all his skills at perspective and conveying emotion in a restrained way, as well as his feeling for narrative drama. The works have been undergoing restoration for several years now, but much has been finished.

A few blocks away, on Corso Italia, is Pieve di Santa Maria, a 12th-century Romanesque church with a lovely façade. Built in cream-coloured stone, its layered arcades narrow as they rise, giving an impression of height; the bell tower "of the hundred holes" was added later. Inside, above the crypt, is a fine 14th-century polyptych of the *Madonna and Child* by Pietro Lorenzetti.

Monterchi and Sansepolcro

If the San Francesco frescoes have given you a taste for della Francesca's work, you could do no better than to venture northeast, to Monterchi and Sansepolcro. The small village of **Monterchi**, just 25 km (16 miles) from Arezzo on S73, is home to his *Madonna del Parto*, a portrait of the pregnant Madonna, an image rarely seen in Italian art. Originally painted for the local chapel, this solemn yet delicate fresco is now on exhibit in a former primary school on Via Reglia; it is a pilgrimage site for both art lovers and pregnant women, who come here to pray for an easy birth.

Sansepolcro, another 10 km (6 miles) along, was della Francesca's birthplace. It's a quiet town whose main attractions are his *Madonna della Misericordia* and *Resurrection*,

When you board a bus, you must validate your ticket in one of the machines on board; if you don't, you can be fined as much as €75. in the Museo Civico. The Madonna, painted around 1440, is the artist's earliest known work; one of the kneeling figures around the Virgin may be the artist's self-portrait. *The Resurrection of Christ*, painted in 1463, is a powerful yet spiritual painting of a muscular

Christ emerging from the tomb.

Cortona and Lago di Trasimeno

If you travel south of Arezzo for just 30 km (18 miles) on S71, a busy local road that serves many farm communities and at points is overlooked by little hillside towns and castles, you will come to what is often and justifiably called Tuscany's most beautiful hill town: Cortona.

The Etruscans were among the first to appreciate the lofty heights upon which Cortona is built, and much of what they left behind, including a bronze lamp, is housed in the town's small **Museo dell'Accademia Etrusco**. What is most striking about Cortona, though, belongs to a much later period, and that is its unspoiled medieval architecture. The town is un-

touched by modern development and unfolds in a series of theatrical piazzas; at its heart, the Piazza Garibaldi opens into the Piazza Signorelli. The town's other treasures also emerged from the medieval centuries—frescoes and panels by Fra Angelico in the Museo Diocesano, across from the Duomo.

One side of Cortona's public gardens opens to a belvedere with sweeping views. As you look south you will notice a body of water glistening in the foreground. This is Lago di Trasimeno, Italy's fourth-largest lake. Its shallow waters are surprisingly clean and, in summer, full of swimmers, boaters, and wind-surfers. There was a day, though, in 217 B.C., when the lake waters ran red with the blood of the Roman legions, more than 16,000 of whom were slaughtered by Hannibal's troops in one of Rome's worst defeats.

Today the scene is considerably more peaceful, especially on the southern shore, which is generally less crowded. A number of fine fish restaurants front the lake.

SOUTHERN TUSCANY

The subject of southern Tuscany summons up superlatives from many observers—enchanting, bucolic, magical—and they don't exaggerate. If, in your mind, you can superimpose these words on a landscape shaped by vineyards, solitary farmhouses, and medieval castles, you'll have a good idea of what awaits you. It's best to see the region by car; you might consider making Montepulciano your base and exploring outward.

Montepulciano

The highest of the hill towns, Montepulciano is set on a ridge. Montepulciano is 125 km (75 miles) south of Florence and is easily reached via the A1 autostrada. If you are coming from Cortona or its environs, take N146 west across the Valdichiana, a trip of about 35 km (21 miles).

Montepulciano is largely Renaissance in character, and much of what stands today was built by architects from Florence after 1511, when the city joined the Florentine empire. Its centre is the Piazza Grande, placed on the highest spot in the city. The Palazzo Comunale, on the piazza, is a 14thcentury version of Florence's Palazzo Vecchio; its tower provides a marvelous view as far as Siena. The 17th-century Duomo, also on the square, has no façade to speak of because the city ran out of money. Its interior is surprisingly elegant, however, and contains two sights of interest. The monumental tomb for papal secretary Bartolomeo Aragazzi, designed and carved in the 15th century by Michelozzo, was taken apart in the 18th century, and its pieces are now scattered through the church; note especially the reclining Aragazzi to the right of the central door. And on the high altar is a 15th-century gold triptych by Taddeo di Bartoldo showing the Assumption of the Virgin; it is considered his masterpiece. Another church worth a visit is the Tempio di San Biagio, designed by Antonio da Sangallo the elder in the 16th century. Set outside the city walls on the Via San Biagio, it is classically inspired and built of soft travertine. Its position allows it to be seen from every side.

Of course, Montepulciano is also known for its wine, the Vino Nobile. Wine has been made here since the eighth century, and the town's shops offer the local variety, along with cheeses and meats to go with it. Some have cellars set in ancient underground tunnels; if they do, ask for a tour.

Pienza

Pienza, 24 km (15 miles) to the east on N146, has one of the oddest pedigrees of any town in Italy. It happened to be the birthplace of the 15th-century Pope Pius II, who, upon achieving his eminence, decided to turn the sleepy little vil-

lage into an ideal Renaissance city. With the help of architect Bernardo Rossellino, he set about his project, commissioning the construction of a central piazza, cathedral, papal palace, and town hall. Unfortunately, Pius ran out of money, so the planned city never grew beyond the central square and its surrounding buildings. They remain, however, as an intact and grand example of planned Renaissance architecture, and nothing else like them exists in Italy.

The **Piazza Pio II**, the central square, is more ideal than real, almost a stage set (it was used as one in Zeffirelli's film *Romeo and Juliet.*) The flanking **Duomo** has a Renaissance façade crowned with the Pope's family coat of arms. The interior is Gothic in style; note the five altarpieces painted by artists from Siena, on the theme of the Madonna and Child

and the Assumption. The tall windows allow a flood of light. The Palazzo Piccolomini, the finest palace on the square, was designed to provide a view, which you can appreciate from the first-floor papal apartments.

Montalcino

Montalcino, 20 km (12 miles) west of Pienza on N146 and N2, is set on a hill under the silhouette of a perfectly preserved castle, and

Montepulciano's Palazzo Comunale tower rewards visitors with a great view.

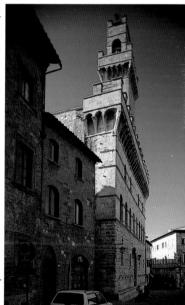

from a distance this walled town presents a magical sight. Its fortunes have swung wildly throughout history. An ally of Siena (which is just 53 km/32 miles to the north up the N2), it became the last bastion of the republic in 1555, when for four years a small group of Sienese exiles fought off the Florentines. Succeeding centuries saw the decline of the town into a malaria-infested backwater. In the past few decades, however, its fortunes have rebounded, fueled primarily by the local Brunello wine - more on this later.

The 14th-century Sienese fortress is quite un-war-like these days: inside its walls are a public park and a wine shop, and its ramparts provide wonderful views. Just down the Via Ricasoli is a newly built Museo Civico. It holds an anonymous painting of the Crucifixion that dates to the 12th century and is one of the oldest pieces of Sienese art extant; also note two illuminated 12th-century Bibles. The town boasts a handful of churches, all of equal interest. Near the Piazza Garibaldi is the Palazzo Comunale, which is the headquarters of the town's wine consortium and offers a small display on the history of local wine-making.

Montalcino has made wine for centuries, but Brunello, developed in the late 19th century, is a relatively recent addition to its output. It has become one of Italy's premier reds, and has turned Montalcino from nearly the poorest to one of the richest towns in Tuscany. Some of the surrounding vinevards-among them Poggio Antico, Banfi, and Fattoria dei Barbi—welcome visitors.

Monte Oliveto Maggiore

North of Montalcino is the centre of a region called Le Crete. where tumulus-shaped hills, stands of cypress trees, and deep ravines form a weirdly beautiful landscape. Monte Oliveto Maggiore, 15 km (9 miles) from Montalcino, is set here (follow N2 north to the town of Buonconvento, and from there SS451 to Monte Oliveto). The monastery, reached through a gatehouse adorned with terra-cottas by the 15th-century Florentine sculptor Luca della Robbia, was founded around 1200 by a Sienese man who, after going blind, took the name Bernardo and came here with two companions to live a solitary life. He attracted followers, and the group was soon recognised by the Church as the Olivetans—otherwise known as the white Benedictines. Over the next few centuries, the monastery became one of the most eminent in Italy and home to a remarkable series of frescoes showing the life of Saint Benedict. Started by Luca Signorelli in the late 15th century and finished by Il Sodoma in the 16th, they are in the great cloister of the monastery, and well worth a careful perusal.

This fairy-tale vista of castle and walled town greets the visitor to wine-rich Montalcino.

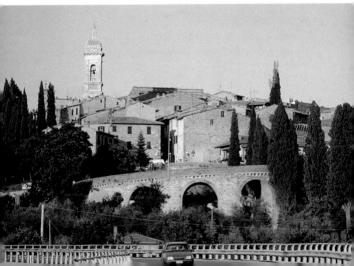

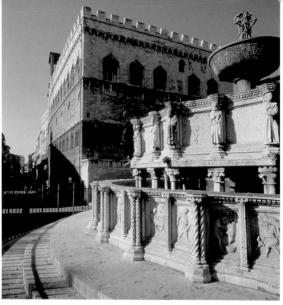

Perugia's Palazzo dei Priori and the Fontana Maggiore, where townspeople once collected their water.

INTO UMBRIA

Umbria is a verdant, spiritual region. Its fields and forests roll across the central Italian landscape; when viewed from the belvederes of Umbria's proud medieval hill towns it seems to be tidily divided into countless little plots. Perugia is a convenient transit hub for the rest of Umbria, and worthy sites surround it like spokes on a wagon wheel.

Perugia

This capital city of rural Umbria is a stylish, dynamic place where chocolates and pasta are made and a sense of modern urban life predominates. Its medieval centre, however, is worth a visit, and its art museum is among the best in the country. Perugia is 155 km (94 miles) south of Florence via the A1 autostrada and 75 bis.

The main drag, the Corso Vannucci, is a superb spot to watch the Perugians go about their business; it also bisects the city and runs directly to the **Palazzo dei Priori**, the city's enormous town hall. Built between the 13th and 14th centuries of local travertine stone, the Palazzo presents an imposing façade, with its Gothic doorway and many rows of windows.

On the upper floors is the **Galleria Nazionale**, which contains a superb collection of Umbrian art. The 30-odd rooms offer a fascinating chronology of the origins and development of the region's art. A few works are especially noteworthy. Duccio's *Madonna and Child* has a quiet beauty. The triptych *Madonna and Child with Angels and Saints*, by Fra Angelico, is boldly coloured in blue. Piero della Francesca's *Polyptych of Sant'Antonio* has a remarkably delicate Annunciation scene at the top of the main painting. And a group of altarpieces by Perugino show the development of his style; note especially his *Pieta*, painted around 1475. Also in the Palazzo is the Collegio del Cambio, a well-preserved Renaissance guildhall with frescoes are by Perugino.

The Palazzo fronts on the **Piazza IV Novembre**. The Romans built a reservoir here; later, the medieval citizens filled it in to create a large open space that became the hub of the city. Providing a lovely centrepiece is the Fontana Maggiore. Designed in the 13th century by Fra'Bevignate and constructed by Nicola and Giovanni Pisano, it collected water from a local aqueduct for the use of the townspeople. Sculpture depicting the history of the city surrounds its base; note the lion and the griffon, symbols of Perugia.

Tuscany

The **Duomo**, also on the piazza, has a rather plain façade and a surprisingly characterless interior. If you are in Perugia on 29 or 30 July, you may be able to see one of the cathedral's most-valued treasures—a ring that is allegedly the Virgin's wedding band, a relic housed in the Cappella del Sant'Agnello and displayed with great fanfare on those dates.

Gubbio

Gubbio, 39 km (24 miles) to the northeast on S298, is a bit remote, but well worth the effort to reach. It is so well preserved a medieval town that it has earned the unfortunate nickname "the Umbrian Siena". But its setting is what places it apart: the Apennines tower behind it, a wild gorge courses through it,

An interior view of the Palazzo dei Priori, which houses an excellent collection of Umbrian art.

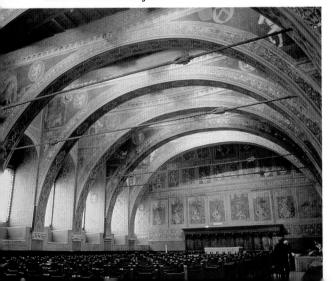

and a bare plain stretches in front. The central square is the Piazza Quaranta Martiri, named for the victims of a Nazi reprisal for partisan activities. On the piazza, the Gothic church of San Francesco contains a fine series of frescoes depicting the life of the Virgin Mary. Saint Francis is supposed to have slept in the sacristy chapel during a visit here.

If you walk east, along the Via della Repubblica, you'll reach the **Palazzo dei Consoli**, a stone and battlemented palace with a towering campanile that stands on the Piazza Grande, which provides a wide view of the town and plain below. An archeological museum in the palace contains a good collection of Roman artifacts, and the Eugubian Tables, bronze tablets inscribed in the ancient Umbrian language.

However, it would be a shame to spend too much time indoors in Gubbio. From the palace, you might wish to wander farther east, to the **Duomo**; step inside to admire its unusual interior vaulting, and then into the adjacent **Palazzo Ducale**, whose recently restored rooms have a calm, Renaissance air. A street behind the palace leads up to Monte Ingino, which provides a fabulous view after a steep climb. (You can also take the funicular.)

Assisi

The birthplace of Saint Francis, 27 km (17 miles) east of Perugia on S75, is one of the holiest and most popular pilgrimage sites in Italy. But don't be put off by its popularity. This tiered village, on the flanks of Monte Subasio above valleys of olive groves, has a visual and spiritual elegance that has survived the onslaught of postcard stands.

Saint Francis was born in the 12th century and, during his lifetime, gained permission from the Pope to create a new order of monks. Shortly after his death in 1226 work began on the **Basilica di San Francesco**, which today stands as monu-

mental building on the eastern edge of the city, containing some of the masterworks of Italian art. Following are a few highlights. (The lower church is open daily from 6:15am to 6pm; the upper church is open daily from 8:30am to 6pm.)

In the lower church are Simone Martini's frescoes in the Cappella di San Martino; painted in the early 14th century, those in the outer chapel depict several saints, while those in

In August, the sign you will see most often is *chiuso per ferie* (closed for holidays). the inner chapel trace the life of Saint Martin of Tours. They display the artist's skill at creating richly patterned fabrics. Stairs halfway along the nave lead down to the

crypt where Saint Francis' plain coffin rests. The Cappella della Maddalena, the last chapel on the right, is decorated with frescoes depicting the life of Mary Magdalene, by Giotto. Finally, note the portrait of Saint Francis by Cimabue in the right transept; it is probably the best-known portrait of him.

The upper church is filled with light; pride of place is given to the frescoes by Giotto on the nave, illustrating the life of Saint Francis. The 28 panels were probably completed at the end of the 13th century. Giotto was a member of Saint Francis's lay registry, and his paintings reveal enormous sympathy for this humble, joyful man. Note also the Crucifixion by Cimabue in the transept, a peculiarly dramatic telling of this story.

In 1997 several earthquakes shook the church, causing the collapse of part of the ceiling, killing four people, and damaging some of the frescoes. Restoration may still be underway.

Outside the church again, head east toward the **Piazza del Comune**. This was probably the site of the Roman forum, and six Corinthian columns from the first-century Roman Temple of Minerva still stand here, now incorporated into a rather ho-hum church. There is much more to see in Assisi, but two more sights deserve special mention. The **Rocca**

The beautiful Basilica di San Francesco still stands proud, despite damage from the earthquakes of 1997.

Maggiore is set high above the city at the end of a maze of medieval lanes, to the north of the Piazza del Comune. The castle was probably erected on old defensive walls built by Charlemagne; what stands today dates to the 14th century. And 4 km (2½ miles) outside the city walls, through the Portao Cappuccine, is Eremo delle Carceri, the hermitage where Saint Francis meditated and prayed. It is still inhabited by Franciscan monks, who will provide a tour of the saint's bed of rocks and the ancient tree under which he preached sermons to the birds.

Spoleto

This lovely little city 63 km (39 miles) southeast of Perugia (take routes 3 bis and S418), is set beautifully on terraces up the flank of a green hill. On the way to Spoleto, though, the marvelous hill town **Todi** is worth a stop; it is 47 km (29 miles) south of Perugia on 3 bis. Todi's central **Piazza del Popolo** has been lauded as the most perfect medieval square in Italy. Spa-

Tuscany

cious, flanked by the Duomo and three 13th-century palaces, it has a visual unity and appeal that makes it unique.

Spoleto has a fine Roman amphitheatre, some lovely churches, and a June music festival that has become the chief attraction for hordes of visitors. The Festival dei Due Mondi, started by composer Giancarlo Menotti in 1958, runs for two weeks in June, and draws a myriad of internationally known dance, music, and theatre groups, along with some avantgarde companies. The festivities have spilled over into preceding months, when classical music is featured, as well as into succeeding months, when opera takes over. Tickets and accommodations should be booked well in advance.

Spoleto provides other pleasures as well. On the edge of the lower town, **San Salvatore**, dating to the fourth century, is one

The terraced town of Spoleto hosts a music festival each June that draws top artists from all over the world.

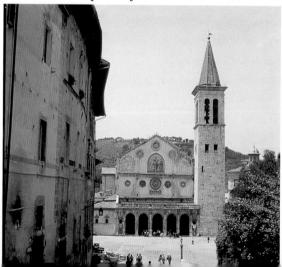

of the oldest churches in Italy. The church is somewhat musty, but highly atmospheric, with its Corinthian columns, bare walls, and stone floors. Also in the lower town are the remains of a Roman amphitheatre. The Romans built special gutters to accommodate the flow of blood from *their* festivities.

In the upper town, the 12th-century **Duomo**, on the Piazza del Duomo, has an unusual mosaic façade, built in the early 13th century by Solsternus. Inside is a fresco cycle on the life of the Virgin by Filippo Lippi; this was his last work; he died in 1469, just before finishing it. Note especially the beautifully coloured *Incoronation of the Virgin*, and the central panel, the *Dormition of the Virgin*, in which Filippo has painted himself wearing a black tunic and a white robe. Just east of the Duomo, take the Via del Ponte around the fortress to the **Ponte delle Torri**. This 13th-century engineering marvel stretches 230 m (760 feet) across a valley, supported by nine stone pillars.

Orvieto

A nice way to approach Orvieto, 86 km (54 miles) southwest of Perugia, is via a very pretty road, S448, which cuts west from Todi and winds around Lago di Corbara. The A1 autostrada between Florence and Rome also zooms past the base of the city; Orvieto is 230 km (130 miles) south of Florence.

While much of the volcanic rock in southern Umbria has been eroded by the Tiber and Paglia rivers, one spire remains unlevelled, and it is on this that Orvieto sits, almost growing from the stone below it and towering over the valley floor more than 1,000 feet below. The city's **Duomo**, set on the city's highest point, is its most spectacular sight, perhaps the most spectacular in all of Umbria. Its cornerstone was laid in the 13th century to mark the Miracle of Bolsena, in which a Bavarian priest on a pilgrimage to Rome witnessed transubstantiation—he saw blood dripping from the Host onto a cloth as he

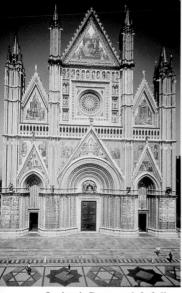

Orvieto's Duomo rightfully claims the highest point of this elevated city.

attended mass in a church on nearby Lago di Bolsena. The cloth was taken to Pope Urban IV, who was in Orvieto at the time, and he ordered the construction of a great church to commemorate the event.

The original architect was probably Arnolfo di Cambio, although work continued on the Duomo for some 300 years and what stands today is an amalgam of some of the greatest talents of the period, including most notably Lorenzo Maitani. The façade consists of four huge pillars supporting a wild array of sculptures, spires, and doorways. The pillars, designed by Maitani, depict detailed scenes from

the Bible; note especially Cain killing Abel.

Inside, head for the altar. To the right is the Cappella della Madonna di San Brizio, decorated by frescoes by Fra Angelico and Luca Signorelli. Fra Angelico completed two sections of the ceiling, showing Christ and the prophets, in the 15th century and was called away to Rome. Signorelli finished his work, then covered the walls with a remarkable series of frescoes. Note especially his *Last Judgment*, which provided inspiration for Michelangelo's painting in the Sistine Chapel, and his *Damned in Hell*, a terrifying scene of what may await the worst among us.

WHAT TO DO

Looking at some of the Western world's greatest artistic achievements—perhaps with time out for an excellent meal here and there—could well fill your days and nights in Tuscany and Umbria. There are, however, also many other activities to occupy you (see also GUIDES AND TOURS on page 120 for some opportunities to combine travel with learning and pursuing special interests).

SHOPPING

"To shop" is what draws many travellers to Italy, and to Florence in particular. While it would be a shame to limit your

Whether you're shopping or visiting the sights, two important words to know are aperto (open) and chiuso (closed).

explorations of Tuscany and Umbria to the regions' shops, however attractive they are, you will be enticed by the quality and design of the worldly goods available. Whether it's high fashion, stationery, leather goods, ceramics, or one of the other

products for which Italy is justifiably famous, you will find it in Florence or elsewhere in Tuscany and Umbria.

Florence

High fashion. Florence is next to Milan in its fashion sense. Many fashion shows are held here in the fall, and many designers have outlets in Florence, many of them on Via Tornabuoni and Via della Vigna Nuova. Yes, these shops are expensive, but most Italian designer goods—whether an Armani suit or a Gucci bag—are less expensive, and considerably so, in Florence than they would be in London or New York.

Gold and silver. Florentines are well known as silversmiths and goldsmiths, and they continue to dispense lovely jewellery

from the expensive shops along the Ponte Vecchio. You will also find many excellent jewellery shops on and around Via Tornabuoni, but what you won't find, except perhaps at a flea market (see pages 87–88), is a bargain on these goods.

Leather goods. A leather centre since the Middle Ages, Florence continues to delight visitors with its vast array of gloves, bags, shoes, and other accessories. You may be tempted by the array and the prices at the Mercato San Lorenzo and the Mercato Nuovo (see page 30), but you'll probably be less pleased with the quality. These are, however, good places to stock up on lipstick cases and coin purses, inexpensive and popular gifts. An interesting place to shop for leather goods is the leather-working school attached to the church of Santa Croce. Some of the best leather shops are clustered along the Arno between the Ponte Vecchio and Via Tornabuoni.

Stationery. Paper goods are among the more interesting Florentine specialties. Diaries, journals, decorative papers, and the like are well made and stunningly designed. Some Florentine shops (such as Il Papiro on Via dei Tavolini and Pineider on Piazza della Signoria) have opened outlets in London, New York, and other cities, but their offerings tend to be less expensive here in Florence.

Around Tuscany and Umbria you will find enticing goods in just about every town throughout the region. The following are especially well known for the products of their artisans.

You will have no problem finding the famous gaily coloured and patterned Derutaware ceramics for which the Umbrian town of **Deruta** is well known. There are more than 70 shops within the old town and along the roads leading into it. One of the workshops where you can see the ceramics being made is Fabbrica Maioliche Tradizionali, Via Tiberina Nord 37. Artisans from **Gubbio** perfected the art of glazing majolica centuries ago, and today the town remains of Italy's major

The Piazzale Michaelangelo offers a great view of Florence
—and the opportunity to purchase some souvenirs.

ceramics centres. You can find excellent wares made by local artisans at Fabbrica Ranimi and Fabbrica Mastro Giorgio, both on Via dei Consoli. Dozens of shops around **Voltera** sell alabaster objects, from ashtrays to grapes and other fruit to lamps, and much of it is very attractive. To see a nice representation of the output of the town's alabaster artisans, visit the Cooperativa Artieri Alabastro on Piazza dei Priori.

Antiques and Flea Markets

Florence is one of Italy's major antiques centres, with many shops clustered across the Arno from the centre of the city, in the neighbourhood known as Oltrarno. For high-quality antiques or attic castoffs, you may also want to browse in the antiques fairs and flea markets in the following towns.

Arezzo: Antiques fair, one of Italy's largest, first Sunday of every month in Piazza Grande.

Arezzo's Piazza Grande hosts one of Italy's biggest antiques fairs each month.

Florence: Flea market weekdays and last Sunday of the month in Piazza dei Ciompi. Flea market on Piazza Santo Spirito second Sunday of the month.

Gubbio: Antiques fair, third weekend of the month.

Lucca: Flea market, second Sunday of the month in Piazza San Martino. Antiques market, one of Italy's most attended, third Sunday of every month in and around Piazza San Giusto.

Weekly Markets

Many Tuscans and Umbrians rely on their towns' markets to stock up on everything from shoelaces to

salami. Held at least weekly and sometimes more often in most towns of any size, markets afford travellers a chance to peruse local foods and observe local customs. Most are held in the morning.

Some of the large markets include: Assisi, Saturday; Chiusi, Tuesday; Cortona, Saturday; Gubbio, Thursday; Massa Marittima, Wednesday and Saturday; Montepulciano, Thursday; Orvieto, Thursday and Saturday; Perugia, weekdays and Saturday; Pienza, Friday; Pisa, daily; Portoferraio (Elba), Friday; Prato, Monday; San Gimignano, Thursday and Saturday; Siena, Wednesday; Spoleto, Friday; Volterra, Saturday.

FESTIVALS AND SEASONAL EVENTS

Just about every town in Tuscany and Umbria enjoys a good *festa*, whether it's to honor a saint or a centuries-old tradition. Here are some of the major festivals, but there are many, many more.

January–February: Several towns celebrate *carnevale*, most notably San Gimignano, where there is a colourful procession, and Viareggio, on the coast north of Livorno, where the pre-Lenten celebrations go on for three weeks.

Holy Week: Assisi and many other towns note this solemn religious period with special observations. In Gubbio, on Good Friday a haunting procession of the Dead Christ is accompanied by chanting.

Easter: During Scoppio del Carro (Explosion of the Cart) in Florence, high mass in the Duomo ends with a bang: a mechanical dove is released from the altar and sets off an explosion in a cart filled with fireworks in the piazza out front. Meanwhile, from the Donatello-designed pulpit in its duomo, Prato displays its most precious relic, the girdle (belt) of the Virgin Mary; the garment is brought out again on 1 May, 15 August, 8 September, and Christmas Day.

Mid-May: In Gubbio's Corso dei Ceri, a procession of torch-bearers races to the top of Mount Ingino.

First Sunday after Feast of the Ascension: Florentines flock to Cascine park to purchase crickets, which they in turn release in the park.

16 and **17** June: Pisa celebrates the feast of its patron saint, San Ranieri, by lining both side of the Arno with candles.

Last Sunday in June: Local rivalries are acted out in Pisa: groups from either side of the river Arno, which divides the city, try to take possession of the Ponte di Mezzo by rolling a seven-ton cart onto their opponents' turf.

- **2 July**: In Siena, bareback jockeys from the city's *contrade* (neighbourhoods) race around the *Campo*, the city's central piazza. The winner receives the *palio* (banner), which lends its name to this world-famous event (it is run again on 16 August).
- 25 July: Pistoia revives its ages-old Giostra del Orso, once a real bear-baiting contest; today the kinder, gentler event features horsemen who attack bear-shaped targets.
- **15** August (Ferragosto): The Feast of the Assumption is a day to relax, for it marks the first day of vacation for those few Italians who do not take the entire month of August off. Cortona celebrates with a *sagra* (feast) in which tons of beefsteak (excellent quality, from herds in the Valdichiana below the town) are served up in the public gardens.

Last Sunday in August: In Montepulciano, the steep main street tempts local lads to join the Bravio delle Botti, in which they roll an enormous barrel up its length.

- **18 September:** Lucca celebrates the Feast of Santa Croce by parading its precious relic, the Volto Santo (a crucified figure of Christ said to have been carved on the scene by Nicodemus) through the streets in a candlelight procession; a fair follows.
- **3 and 4 October:** Assisi celebrates the feast of Saint Francis with processions, outdoor meals, and musical performances.

Late October: Gubbio honors and offers for sale its precious white truffles in a lively fair.

- **13 December:** Siena celebrates the feast of Santa Lucia with a huge pottery and ceramics fair.
- **24 December**: In Camporgiano, near Lucca, an immense pile of evergreens is set ablaze. Not burned is a giant Christmas tree, said to the world's tallest, in Gubbio.
- **26 December**: Prato celebrates its patron saint, Stephen (San Stefano), with a showing of the city's famous relic, the girdle (belt) of the Virgin Mary, accompanied by much pomp and ceremony.

SPORTS AND OUTDOOR ACTIVITIES

With their long summers and pleasant autumns and springs, Tuscans and Umbrians have ample opportunity to spend time outdoors. Here are some pursuits in which you might want to join them.

Swimming. The most enjoyable swimming is from the beaches on Elba, especially from the unspoiled strands around the hamlets of Nisporto and Nisportino. The best of the less-inspiring beaches on the mainland are probably those around San

This crossbow was once used for hunting—there are safer sports to enjoy here, though.

Vincenzo, south of Livorno. There are several beaches on the shores of Lago di Trasimeno in Umbria, though they tend to be reedy; the best is at Castiglione del Lago on the western shore.

Golf. There are several golf courses near Florence (one of the best in the region is Golf dell'Ugolino near Impruneta in Chianti country; Tel. 055/230 1009).

Hiking. In Tuscany, the mountainous region around Carrara provides some of the most challenging hikes. In Umbria, the countryside around Spoleto is good for hiking. Most tourist boards will provide a list of hikes in the area, or you can contact the office of Club Alpino Italiano in Florence at Via dello Studio 5, or in Perugia at Via dell Gabbia 9.

Horseback riding. The terrain along the Tuscan coast is quite popular with equestrians. Two stables are Rigugio

Prategiano, in the town of Montieri near the city of Grosseto, Tel. (0566) 997 703, and Le Cannelle, also near Grossetto in the Parco dell'Uccellina, Tel. (0564) 887 020. For more information about where to ride, contact the equestrians at Federazione Italiana Sport Equestre (Italian Sport Riding Association), Via Paoletti 54, Firenze; Tel. (055) 480 039.

Spectator sports. Florence has a *calcio* (soccer) team that plays its home games at Stadio Comunale; tickets, which can be hard to come by, are available at the Chiosco degli Sportivi on the Piazza della Repubblica. If you are in Florence on or around the feast of Saint John (late June), you may want to catch the Calcio in Costume, where you can see a rough-and-tumble medieval version of the game played in period costume.

MUSIC AND THE PERFORMING ARTS

Tuscany and Umbria host a number of events showcasing music and the performing arts. Check with local tourist boards (see page 128) for lists of events; in many towns you may stumble upon a one-evening-only concert or performance.

Florence has a fall-through-spring schedule of concerts, operas, and dance performances at its two major venues for the performing arts: the Teatro Comunale, on Corso Italia, and Teatro Verdi, on Via Ghibellina.

Tuscany and Umbria are favoured settings for many internationally renowned music festivals. Città di Castello draws visitors from around the world for its Festival delle Nazioni di Musica da Camera (International Chamber Music Festival) during the last week of August. Florence spreads its Maggio Musicale (Musical May) into June as well, hosting concerts and dance performances in palazzos, churches, and other atmospheric venues around the city. Lucca stages a music festival from April through June. The Settembre Lucchese in September is a month-long series of operatic

and other musical performances. Montepulciano hosts the Cantiere Internazionale d'Arte, a major music and theatre festival, in July and August. Perugia hosts two major musical festivals, Umbria Jazz in July and the Sagra Musicale Umbria in September. Siena's Settimane Musicali Senesi, in July and August, stages concerts in churches and piazzas throughout the city. Spoleto's Festival dei Due Mondi (Festival of Two Worlds) is one of the world's most highly acclaimed musical events, drawing classical artists, dancers, and others in June and July.

TRAVELLING WITH CHILDREN

In few countries in the world are children as well received as they are in Italy, and there are many child-pleasing diversions in Tuscany and Umbria. A short list includes, but is not limited to:

In Florence. A walk in Cascine park or the Boboli gardens; a climb to the top of the dome of the Duomo; a walk across the Ponte Vecchio; a trip up to hilltop Fiesole on the number 7 bus for the views and a look at the Roman ruins.

And elsewhere. The trip through Chianti country, with its pleasant scenery, to Siena, for a climb to the top of the Torre di Mangia overlooking the Campo, the city's elegant central piazza, is an excellent child-pleasing excursion. It could also include a stop in nearby tiny Monteriggioni, where the encircling walls evoke tales of knights in armour.

With their medieval walls and towers and narrow alleys, any of the towns and hill towns in Tuscany and Umbria are fun to explore, especially **Gubbio**, for the chance to ride in the open-air funicular up the side of Monte Ingino; **Lucca**, for the chance to walk or ride a bike around the medieval walls; **Orvieto**, for the ascent to it via funicular; **San Gimignano**, for its towers; and **Pisa**, with its perennial favourite, the Leaning Tower.

EATING OUT

The pleasures of the table in Tuscany and Umbria are considerable. In general, the cuisine is basic and rustic, relying heavily on fresh produce and meat and game. The only elaborate sauces you are likely to encounter will be atop pasta—meats are usually simply roasted or grilled. Two words are basic to cooking in Tuscany and Umbria, and those are "olive" and "oil". It is used instead of butter or shortening in cooking, atop bread instead of butter, over salads and vegetables as a dressing—in short, olive oil is used any time a fattier alternative would be used elsewhere, placing the cuisine of Tuscany and Umbria fairly high in the healthy category.

Where to Eat

Trattoria and ristorante—you'll encounter these names on signs over establishments that seem to be similar, but to Italians they signify entirely different types of dining experiences. A trattoria is more casual, serving basic fare in an informal setting; a ristorante implies fancier decor, service that is more formal, and more elaborate and more expensive cuisine. Compounding any confusion this distinction may cause is the fact that many elegant

In Tuscany, c is often pronounced as h, so conto (bill) becomes honto.

eateries call themselves trattorias because of the Bohemian charm that name implies. In fact, some rather elegant establishments are rakish enough to call themselves *osterie*, which in truth

are simple tavern-like wine shops where you can buy a glass of wine from a vat and perhaps a slab of cheese.

Yet another type of eating establishment is the *tavola calda* or *rosticceria*, both of which are cafeteria-style eateries where several selections of hot dishes are prepared daily and served from a counter. You generally pay in advance and show the

The treasures of the deep are abundant in Tuscany.

receipt to someone behind the counter, who prepares a plate for you. Italy being more gracious than many other countries, it is usually the custom for someone to bring the plate to your table rather than handing it to you over the counter.

In general, a ristorante or trattoria serves both lunch and dinner; very rare is the one that doesn't serve both. Lunch is generally from 12:30pm to 3pm, and dinner from 7:30 to 10pm. Occasionally a restaurant will keep later hours, but rarely past 11pm or so. Most establishments close one day a week and occasionally for lunch or dinner immediately preceding or following the closing—so a restaurant that is closed on Monday may also close for Sunday dinner or Tuesday lunch.

Whether it's a trattoria or ristorante (or bar or caffè; see below), most Italian eating establishments have the good sense to close for vacation (*ferie*) once or even a couple of times a year. August is a popular closing month, especially in Florence; many restaurants close for two weeks in the summer and another week or two in the winter. The schedule an establishment fol-

Tuscany

lows is usually well posted near the front door, with a sign showing hours, weekly closing days, and annual closing dates. Most also post their menus and prices out front. In so doing, they provide you with the opportunity to see what you will be getting into before you wander into a restaurant and sit down.

Bars, Caffès, and Gelaterias

Another distinction to keep in mind is the one between bar (bar in Italian) and café (caffè). In Italy, bars are not places to drink alcoholic beverages, as they are in the United States and elsewhere. Actually, bars in Italy do usually serve wine and spirits, but they also tend to dispense soft drinks, mineral water, and, most of all, enormous quantities of coffee. These beverages are accompanied in the morning by pastries (cornetti or briochi, both of which are croissants filled with jam, custard, or chocolate) and throughout the day by little sandwiches (panini) or other light fare. Since all these foods are usually displayed on the counter, you need only point to what you want.

Many Italians will stop by their local bar several times a day for a quick coffee and chat, and you should find one you like and do the same—there's almost no better place in which to observe the engaging drama of day-to-day Italian life. You will be more welcome in a bar if you observe a rule that seems to confuse most non-Italians: in larger bars you do not pay the serving people behind the counter. Instead, you decide what you want to eat and drink, tell the cashier and pay in advance; the cashier will give you a receipt that you present to the bar staff when you tell them what you would like.

Bars keep long hours, usually opening around 7:30 or 8am, often earlier (especially if the clientele is primarily local) to serve breakfast of pastry and coffee, and remain open until the wee hours, often until 2am, to dispense nightcaps or a final shot of espresso.

A caffè is usually an elegant establishment that Americans or the British would be more likely to call a tearoom. Many cities and towns throughout Tuscany and Umbria have at least one august caffè; there are two such places in Florence on the Piazza della Repubblica: Caffè Gilli and Caffè Paszkowski. Caffès serve pastries and other sweets (often ice cream, or *gelato*) and sometimes light meals, accompanied by coffee, tea, or a glass of wine.

On the subject of gelato, most cities and towns of any size in Tuscany and Umbria are blessed with at least one *gelateria*, a shop that sells only gelato and *sorbetto*, which is a refreshing and less-fattening alternative of ice often mixed with fresh fruit. Both are usually available in cups or cones. A gelateria worth seeking out in Florence is the world-famous Vivoli—so famous that there is a postcard on the wall that was successfully delivered though the address line reads only, "Vivoli, Europa". To be more precise, you will find the premises near Santa Croce on Via Isole di Stinche.

Coffee Break

One of the first sensations to delight you in Italy may well be the smell of coffee. When it comes to ordering this ubiquitous beverage, you have several options. A caffè is a single shot of espresso, usually dispensed from an elaborate-looking espresso-maker behind the bar. A double shot is una doppia. Coffee topped with steamed, frothy milk is cappuccino; incidentally, Italians consider cappuccino to be a morning-only drink and find the notion of ordering one after dinner ridiculous. Caffè machiato is espresso with just a drop of steamed milk; caffè latte is espresso mixed with a generous serving of warm milk; caffè corretto is espresso with a shot of alcohol. While coffee is by far the more popular choice, tea (tè) is widely available, served with milk (con latte) or lemon (con limone), and iced (freddo) in summer.

What to Eat

You will notice that just about all menus are divided into more or less the same categories (to an Italian, these are the essential elements of a decent meal): *antipasti* (appetizers), *primi* (first courses), *secondi* (second courses), *contorni* (side dishes), and *dolci* (desserts).

While many Italian diners will include all of these elements in a meal, chances are you will not be shooed out of a place for

A waiter is a cameriere; a waitress is a cameriera. You should address them as signor and signora, respectively.

ordering less—how much less, though, is the question. Never try getting away with ordering only an antipasto, filling as this course can be—to do so would be the same as ordering only a salad or a shrimp cocktail at a restaurant in London or

New York. Ordering a pasta dish or a secondo and a contorno is somewhat acceptable, especially at lunch. What it comes down to is that Italians take dining seriously—not with the same solemnity as their French neighbours, perhaps—but seriously enough that dinner can stretch on for several hours. A meal in Italy is to be enjoyed, and restaurateurs expect their non-Italian patrons to approach it in the same way.

See the list on page 104 for some of the foods unique to Tuscany and Umbria. In addition, here is what you are likely to find on most menus.

Antipasto means "before the meal". and these selections are usually served cold and in small portions. Many restaurants offer an *antipasto mista* (mixed antipasto) that is served buffet-style from a table laden with such dishes as *melone con prosciutto* (ham and melon) or *prosciutto crudo con fichi* (ham with figs), and *insalata caprese* (mozzarella, tomatoes, and basil).

Typical Tuscan antipasti: *crostini*, tomatoes or liver paste on toasted bread; *prosciutto di cinghiale*, ham made from wild boar; *finocchiona*, pork sausage laced with fennel.

Typical Umbrian antipasti: *bruschetta*, toasted bread topped with garlic and olive oil, sometimes with tomato paste as well; *prosciutto di Norcia*, ham from the town of Norcia, Umbria's foremost producer of pork; *schiacciata*, a flat bread sometimes topped with onions and other vegetables.

Primo is the first course, and in Tuscany and Umbria that generally means soup or pasta (increasingly you also find risotto). Soups and pastas are hearty in both regions.

Typical Tuscan primi: acquacotta, onion soup that is a speciality of Arezzo; minestrone alla fiorentina, a vegetable soup with beans; panzanella, Tuscany's version of gazpacho, with ingredients that include tomatoes, basil, and bread; pappardelle con lepre, wide noodles topped with a rich sauce made with hare; ribollita, a rich vegetable soup with bread mixed into it, usually served in winter and often made from left-over vegetables, hence the name "reboiled"; cacciuco, a rich fish soup that is reason in itself to travel to Livorno.

Typical Umbrian primi: minestra di farro, a vegetable soup; tagliatelle con funghi porcini, thick noodles with wild

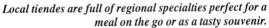

mushrooms; *pici*, a fat, short spaghetti usually served with tomato sauce; *baggiana*, a soup of fava beans and tomatoes.

Secondo is the main dish, meat or fish, more often than not meat in Tuscany and Umbria, and often beefsteak, pork, rabbit, or game birds in both regions. Some typical dishes of both regions are *porchetta*, roast suckling pig, often sold from stalls at markets or on roadsides; *cinghiale*, wild boar, usually roasted or made into sausages called *salciccia*; *fritto misto*, a mixed grill including lamb chops and sweetbreads, among other meats; *anatra*, duck; and *girarrosto*, a spit of roast game birds.

Typical Tuscan secondi: trippa alla fiorentina, tripe with tomato sauce; baccala alla livornese, salted cod, a speciality of Livorno.

Typical Umbrian secondi: *frittata di tartufi*, an omelette made with truffles; *regina in porchetta*, carp from Lago di Trasimeno, covered with herbs and baked in a oven.

Contorno is the vegetable course. It's almost always ordered separately, as vegetables and salad are never included with a secondo. Usually only a few items are offered, but they are almost always fresh from the market that day. *Fagioli*, beans—especially white beans—are a favourite on Tuscan menus, and you will encounter them in Umbria as well. Salads, *insalata*, are

Rating the Wines

Italian wines are classified with three ratings. DOCG (Denominazione di Origine Controllata Garantita) indicates that a wine is from an established wine-producing region and maintains high standards of quality. DOC (Denominazione di Origine Controllata) ensures that a wine is from an established area and meets the standards of that area; it is guaranteed to be a quality wine, but of a lesser quality than a DOCG wine. Vino da tavola, the third classification, more or less denotes a good table wine from a reputable producer.

straightforward and tend to come in two varieties: *insalata verde*, a simple green salad, or *insalata mista*, greens with mixed vegetables.

Dolci is dessert This course is not among Italy's culinary achievements, and the somewhat turgid creof Tuscan ations and Umbrian kitchens are no exceptions. Gelato (ice cream) is reliably delicious when it is homemade, and hiscotti are sweet biscuits. often made with almond, that are dipped in vinsanto, a

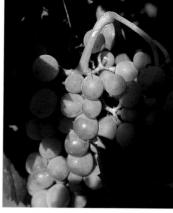

Harvest time is a muchawaited event at Italy's many well-known vineyards.

sweet wine. Many towns and cities have their own sweet specialties that show up on menus and are often for sale in shops.

Typical Tuscan dolci: *cantucci*, small versions of biscotti that are a speciality of Prato; *cenci*, dough that is fried and sprinkled with sugar (often sold from stalls in town markets); *panforte*, a cake of nuts and candied fruit, from Siena.

Typica; Umbrian dolci: *gelato ai Baci*, creamy ice cream with Perugia's famous Perugina chocolates folded into it; *roccoiata*, a cake that has a rich filling of walnuts, almonds, raisins, and honey and that is a speciality of Assisi.

Beverages

Italian beer is quite palatable; ask for a *birra nazionale* and you will probably be served a bottle of Peroni. Many imported brands are also available. Draft beer (*birra alla spina*) is often imported and quite a bit more expensive.

Tap water is generally drinkable throughout Tuscany and Umbria, and in many rural settings comes fresh from wells. Even so, most Italians prefer to drink mineral water (acqua minerale). You will be asked in restaurants if you want one of three types of water: acqua normale, which is from the tap; acqua frizzante, con gas, or gassata, all of which mean mineral water "with gas". which English speakers might know better as "sparkling water"; and acqua naturale or non gassata, mineral water without gas.

While canned soft drinks are becoming more common—Coke and Fanta lemon or orange drinks (Fanta limone or arance) are probably the most prevalent—don't overlook some of the more interesting alternatives. Spremuta is a fresh-squeezed juice, and a favourite remedy for the heat of Tuscan and Umbrian summers is spremuta di limone, a drink of fresh-squeezed lemon to which you can add sugar and water to taste. A bit fancier, and especially popular in the caffès on the Piazza della Signoria in Florence, are granitas. These are wonderful concoctions of crushed ice to which fresh fruit juice or other flavourings are added; a caffè granita is a large glass of coffee-permeated ice topped with whipped cream.

Wine

For many travellers in Tuscany, "wine" is synonymous with "Chianti"; little wonder, since the region produces prodigious amounts of this red wine that is so important to the local economy that in 1716 Grand Duke Cosimo de Medici III himself declared that only certain parts of Tuscany could call their wine Chianti. The type was further refined more than a century later when Baron Ricasoli, a wealthy landowner and part-time politician, began to experiment with the composition of the wine. He hit upon a combination of Sangiovese, Canaiolo, and Malvasia grapes, and adopted a process whereby the wine was

fermented twice. He bottled his concoction in green glass, covered the bottles with woven straw, and entered it in the Paris wine exhibition of 1878. Ricasoli's resultant success spawned a host of rot-gut imitators over the next decades; in response, local vintners carefully specified the geographical boundaries in which Chianti could be produced and adopted the black cockerel as their logo. All wines bearing the logo are now tasted by judges to maintain quality.

Chianti may be Tuscany's most famous wine, but Brunello, from vineyards around the town of Montalcino, is widely considered to be its best. Deep, ruby red, and robust, it must be played off against the strong taste of steak or game. The region's third contender is Montepulciano, a lovely, fruity, easy-on-the-palate red from the town of the same name. Tuscany's best white wine is Vernaccia di San Gimignano.

Though less famous than Tuscan wines, Umbrian wines can hold their own. The best are the delicate whites from Orvieto, notably the dry Orvieto Classico. The wines from Montefalco, especially Sagrantino di Montefalco, are the region's best reds.

To Help You Order...

Here are a few terms that may enhance your dining experiences, some of the greatest pleasures that Tuscany and Umbria offer visitors. Be bold and try to scrape by in Italian—your efforts will be appreciated and possibly rewarded with a complimentary glass of wine.

Buona sera. Good afternoon/evening.
Parla inglese? Do you speak English?

Aperto Open Chiuso Closed

Vorrei una tavola per una/
due/tre/quattro

Do you have a table for one/
two/three/four

due/tre/quattro two/three/for persona/persone? people?

Tuscany

Avete un menu? Quanto costa? Il conto, per favore. Do you have a menu? How much is it? The bill, please.

...And Read the Menu

In addition to the regional specialties discussed on pages 98–101, here are some common terms you are likely to encounter on menus:

aglio	garlic	agnello	lamb
basilico	basil	birra	beer
bistecca	steak	bollito misto	an array of
burro	butter		boiled meats
brodo	clear broth	caffè	coffee
calamari	squid	carciofi	artichokes
cervo	venison	cipolle	onions
coniglio	rabbit	cozze	mussels
fagioli	beans	fegato	liver
finochio	fennel	formaggio	cheese
frittata	omelette	frutti di mare	seafood
gamberetto	shrimp	insalata	salad
lepre	hare	lumache	snails
maiale	pork	manzo	beef
melanzane	aubergine	minestra	soup
panna	cream	pane	bread
patate	potatoes	polipo	octopus
polpette	meatballs	pomodori	tomatoes
peperoni	peppers	pesce	fish
piccione	pigeon	pollo	chicken
prosciutto	ham	rognoni	kidneys
spiedino	skewers of	spinachi	spinach
	meat	te	tea
uova	eggs	vitello	veal
vino	wine	zuppa di pesce	fish soup

HANDY TRAVELTIPS

An A-Z Summary of Practical Information

Accommodation 106		Guides and Tours 118				
	Н	Health and				
		Medical Care 118				
	L	Language 119				
0 0	M	Money Matters 120				
	Ο	Opening Times 121				
Car Rental/Hire 110	P	Police 122				
Climate 110		Post Offices 122				
Clothing 110		Public Holidays 123				
		Public Transport				
		123				
	T	Telephone 124				
		Time Zones 125				
Electric Current 114		Tipping 125				
Embassies and		Toilets 125				
		Tourist Information				
		Offices 126				
	W	Weights and				
/		Measures 127				
	Y	Youth Hostels 127				
	Climate 110 Clothing 110 Crime and Safety 111 Customs and Entry Requirements 111 Driving 111	Airports 107 Bicycle Rental 108 Budgeting For Your Trip 109 Camping 109 Car Rental/Hire 110 Climate 110 Clothing 110 Crime and Safety 111 Customs and Entry Requirements 111 Driving 111 Electric Current 114 Embassies and Consulates 115 Emergencies 115 Gay and Lesbian Travellers 115				

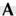

ACCOMMODATION

First, a note on terminology: most Italian lodgings are called *albergo* or *hotel*, which connote exactly the same kind of hostelry. *Pensione* is also used frequently, and this term traditionally suggests a small, family-run establishment. A pensione in Florence, for example, is often, but certainly not always, a large apartment occupied in part by the resident owners, or it can simply be a small hotel. A *locanda* is usually a rural inn, but this term, too, has been appropriated by urban hoteliers eager to add a bit of charm to the names of their properties.

However an accommodation is labelled, it falls into one of the five levels (indicated by stars) of the government rating system. The number of stars reflects the number of amenities offered (in-room bathrooms, lifts, air-conditioning, etc.); the more stars a hotel has been assigned, the more amenities it offers. The star system is strictly objective and does not reflect charm or ambiance. Accordingly, a five-star hotel can be a well-equipped modern city tower catering to business people or a lavish villa in the countryside. Obviously, the more stars an establishment has, the more expensive it will be. Tourist information offices (see page 126) can provide a list of accommodation in most towns, with addresses, phone and fax numbers, number of rooms, amenities, and prices.

Villas, farmhouses, apartments in medieval cities, and other types of rental properties are plentiful in Tuscany and Umbria. Locating one—or at least, locating one in which you will be happy—can be an involving process. Tourist boards sometimes provide information on such rentals, and you can find listings for rental properties in Tuscany and Umbria in many newspapers and magazines (the New York Review of Books, Atlantic Monthly, and in the travel supplements of The Sunday Times and the Daily telegraph in the UK). The internet has made it much easier to locate property for rent in this part of the world, with scores of villa agencies and villa owners promoting their properties through websites that have photographs, descriptions and comments from previous guests. Typing "Villas in Tuscany and Umbria" into a search engine will bring up plenty of choices.

Tourist boards can also provide information on farm accommodations called *agriturismo*. To be labelled as such, an agriturismo must have fewer than 30 beds, and the property must earn most of its income from agricultural pursuits. As a result, you are pretty much assured of staying on a bona fide farm, though accommodations and prices can vary greatly (and are not rated as hotels are). In most you will be served a country breakfast with local cheeses and other products, and you also may be served other meals (almost always featuring homegrown ingredients).

I'd like a single/ double room. With bath/shower What is the price per night? Vorrei una camera singola/ matrimoniale or doppia Con bagno/doccia Qual è il prezzo per una notte?

AIRPORTS (aeroporto)

Tuscany is served by two international airports, one in Florence and one in Pisa. Neither handles nonstop flights from North America or other countries overseas. They do, however, serve flights from airports in London and other European cities, with Pisa handling most of them. Travellers from North America can often fly nonstop from New York or another city to an airline's major European hub and continue on to Pisa from there. If Umbria is your destination, you will probably find it just as convenient to use the Rome airports covered below.

Pisa's Aeroporto Galileo Galilei is connected to central Pisa and to Florence by hourly train service (six minutes to Pisa, one hour to Florence). Trains leave from a station in the terminal complex; if you are leaving from Pisa, you can check your bags onto the flight at a desk inside Florence's Santa Maria Novella train station. For airport information call (050) 500 707. Many rental car agencies, including international firms, have outlets at the airport.

Aeroporto Amerigo Vespucci in **Florence** is 5 km (3 miles) outside the city in Perètola. A bus connects the airport with the bus station in central Florence. For airport information, call (055) 373 498.

Rome is served by two airports: Leonardo da Vinci (better known as Fiumicino, the town 30km/18 miles southwest of Rome on the Mediterranean where it is located) and Ciampino, closer in to the city and used mostly for charter flights.

Tuscany

Leonardo da Vinci handles dozens of international flights a day. The airport is exceptionally well served by public transportation. Trains leave from a station in the terminal complex for Rome's Termini train station (every half hour between 7am and 10pm; $\[\in \]$ 8), and from there you can make connections to Florence, Perugia, and other points throughout Tuscany and Umbria (see page 123). Alitalia, the Italian national airline, also operates a nonstop train service from the airport to Florence.

From Ciampino, you can take a local bus from outside the arrivals terminal to the Anagnini stop on the Metropolitana (Rome's subway system) and from there take line A to Stazione Termini. Taxis from both these airports into Rome tend to be expensive, so you may want to consider using one of these efficient public transportation options.

If you plan to rent a car while visiting Italy, you will find it convenient to pick one up at Leonardo da Vinci's car rental facilities and get on the road immediately. The rental offices are located in a garage structure connected to the terminals by a state-of-the-art system of ramps, escalators, and moving sidewalks. From the airport there is direct and well-marked access to the *raccordo*, the highway that encircles Rome, which in turn takes you to the autostrada A1, the superhighway that runs up and down the country, connecting Rome with such cities in Tuscany and Umbria as Orvieto, Perugia, and Florence; the total travel time from Leonardo da Vinci to Florence is less than three hours.

When is the next plane to...?

I would like a ticket for... Please take these bags to the train/bus/taxi. A che ora parte il prossimo aereo per...? Vorrei un biglietto per... Mi porti queste valige fino al treno/all'aotobus/al taxi, per favore.

B

BICYCLE RENTAL (noleggio biciclette)

The countryside of Tuscany and Umbria is prime cycling terrain, and there are rental outlets in many cities and towns. Before setting out, serious bikers may want to contact Federazione Italiana Amici della Bicicletta, Corso Regina Margherita 152, 10152 Turin, Tel. (011) 521

2366, for information on where to find the best routes and how to meet up with other cyclists. Local tourist boards also provide a wealth of information on this popular Italian pastime. In Florence, bicycles can be rented at the stand at the corner of Via Calimali and Via Orsanmichele (summer only) and ridden on the new bike lanes appearing throughout the city centre. In Lucca, where the bicycle is the most popular form of transportation, there is a stand on Piazzale Verdi.

BUDGETING for YOUR TRIP

When determining your budget, think of Florence and the rest of Tuscany and Umbria as two separate entities. Florence is expensive, while the rest of the regions are moderate in terms of cost. In Florence, for example, you can expect to pay &80 to &130 for standard double accommodation. Outside Florence, you can probably find the same room for &60 to &100.

However, meals are not terribly expensive in Florence or anywhere else in Tuscany and Umbria. Depending on where you eat, of course, you can usually enjoy an excellent meal for two (excluding wine) for about 650; a lunch of pizza or a salad will be about half that. Museum entry fees run in the 62.50 to 68 range, while even in Florence the bus fare is less than in most European cities: 61. Coffee and soft drinks are expensive 65 to 68 is not uncommon) in an outdoor café in a prime location, such as one of the major piazzas in Florence, but they are much less, rarely more than 61, at a bar frequented by locals.

C

CAMPING

Camping is permitted only in designated areas—usually crowded and not particularly appealing spots. The campground near Florence is an exception in that it occupies a hillside above the Arno near Piazzale Michelangelo. Contact Camping Michelangelo, Viale Michelangelo 80, 50125 Firenze; Tel. (055) 681 1977. There is also a very beautiful campsite set on a hillside above Florence on Via Peramonda, in Fiesole; Tel. (055) 599 069. Tourist information offices (see page 128) include campgrounds in their accommodations listings.

Tuscany

CAR RENTAL/HIRE (autonoleggio)

One sure way to save money when renting a car in Italy is to make arrangements before leaving home; in doing so, you will be ensured rates that are usually half of what they would be if you rented a car on the spot. All major companies (Avis, Budget, and Hertz) have outlets in Italy and provide very competitive rates, especially for rentals of a week or more; if you shop wisely in the US, for example, you may find rates of \$300 a week for a small car with standard transmission. Expect to pay considerably more (often double) for a car with automatic transmission and air-conditioning. A tax of 19 percent is added to all car rentals, as is a surcharge of 10 percent if you pick up your car and drop it off at the airport.

CLIMATE

Tuscany and Umbria are not given to great extremes of climate, although it can be hot (especially in low-lying areas) in July and August. A hillside offering cooler temperatures and a refreshing breeze is never too far away, however; in August, there can be a 5 to 10 degree difference in temperature between Florence and nearby, hilltop Fiesole. Winters are chilly but rarely bitterly cold, and snow is pretty much confined to the highest hills. Spring is long (March through May) and very pleasant, while fall is pleasantly mild but can be rainy.

Approximate monthly average temperatures are as follows:

		J	\mathbf{F}	\mathbf{M}	A	M	J	J	A	S	O	N	D
°C	max	9	12	16	20	24	29	32	31	28	21	14	10
	min	2	2	5	8	12	15	17	17	15	11	6	3
°F	max	48	53	59	68	75	84	89	88	82	70	57	50
	min	35	36	40	46	53	59	62	61	59	52	43	37

CLOTHING

Italians dress well, and although they have become inured to the sight of tourists clad in shorts and T-shirts tromping through their piazzas, they will treat you with a little more respect if you dress as they do—trousers and short-sleeved shirts for gents in the summer, and trousers and blouses, skirts, or dresses for women. From October through April you will need a sweater or two and a raincoat. Only the more expen-

sive restaurants require jacket-and-tie formality, but you will want to dress well, even if casually so, for dinner. Shorts and sleeveless T-shirts are not proper attire for a church visit—in fact, at many churches a guard is posted at the front door to check for immodest attire.

CRIME and SAFETY

Tuscany and Umbria are relatively safe, though pickpocketing or purse-snatching are now commonplace in Florence, so take great care with your valuables at all times. Some common heists are those perpetrated by gypsy children or women carrying babies, who surround you and create a distracting commotion while cleaning out your pockets. Vespa-riding bandits, who snatch purses while whizzing by at high speed, are also a menace.

I want to report a theft. My wallet/passport/ticket has been stolen. Voglio denunciare un furto. Mi hanno rubato il portafoglio/ il passaporto/il biglietto.

CUSTOMS (dogana) and ENTRY REQUIREMENTS

Citizens of EU countries need only a valid passport or an identity card to enter Italy. Citizens of the US, Canada, Australia, New Zealand, and South Africa need only a valid passport, though a special visa or resident permit is required for stays of more than 90 days. To facilitate the replacement process in case you lose your passport while travelling, photocopy the first page of your passport twice; leave one copy at home, and keep another with you, but separately from the passport.

EU regulations now allow for the free exchange of goods for personal use between member countries. For residents of non-EU countries, the following restrictions apply:

Currency restrictions and the IVA tax. While there is no limit on the amount of currency you can bring into Italy, you must declare any currency over the amount of €10,000 upon leaving the country.

IVA. A Value Added Tax of 12 to 19 percent is added to all purchases in Italy. In many cases, residents of non-EU countries can claim a refund for part of this tax on purchases of more than €150 at one store —if they are willing to follow some complex procedures. These involve having customs officials at the airport stamp the receipt as you

depart Italy and mailing the stamped receipt back to the store within 90 days of purchase; the store will mail you a refund. A simpler "Tax Free for Tourists" plan is now being adopted by many stores: the store will issue you a receipt and check, which you can redeem at the airport once you present your receipt to customs and have it stamped.

Into:	cigarettes		cigars		tobacco	alcoho	1	wine	beer
Australia:	250	or	250g			1l			
Canada:	200 a	nd	50	and	400g	1.14l	or	1.1 <i>l</i> or	8.5l
N. Zealand	1 : 200	or	50	or	250g	11	and	4.5 <i>l</i> or	4.5l
S. Africa:	400 a	nd	50	and	250g	11	and	21	
US:	200	or	50	or	2kg	1l	or	1l	

D

DRIVING

Italy's roads are extremely well marked and meticulously maintained. The major hazards are your fellow motorists, who tend to drive fast and often recklessly. Two words of advice: drive defensively.

Drive on the right (for this reason, motorists from the UK may want to rent a car in Italy rather than using their own) and pass on the left. At intersections and traffic circles (roundabouts), traffic on the right has the right of way.

Drivers from the US, Canada, UK, Australia, New Zealand, and South Africa require only a valid license from their home countries (an international driver's permit is no longer required). Motorists bringing their own cars into Italy must have an official nationality sticker displayed in the rear of the vehicle, an international motor insurance certificate, and a vehicle registration document. EU residents must have a green insurance card, which will greatly facilitate matters in case of an accident. Drivers and all passengers must wear seat belts, and motorcyclists must wear helmets. All cars must be equipped with a red warning triangle in case of breakdown. If you bring a car into Italy from the UK or the Republic of Ireland you must adjust the headlights (lamps) for right-side driving.

Italy's superhighways, called *autostrade*, are four- to six-lane toll roads on which the maximum speed (rarely observed) is 130 km/h (80 mph). Slower traffic should keep to the right and venture into the left

lane only when passing (overtaking); should you linger there, inevitably a faster-moving car (more often than not a Mercedes-Benz) will roar up from behind flashing its headlights, an indication to move over quickly. The A1, Autostrada del Sole, cuts through Tuscany and Umbria on its run up the peninsula from Naples to Milan, providing quick connection with Rome and the rest of the country. On this and other autostradi, a machine dispenses a ticket at entrances; when you exit you pay the toll for the distance you've travelled (at most exits, you can pay by inserting the ticket and a credit card into a toll machine, though there is always at least one manned booth at every exit). Tolls tend to be expensive—from Rome to Florence, for example, the toll is around €10. On all autostradi there are frequent rest stops, with gas (petrol) stations, restaurants, shops, and bars.

The speed limit on secondary roads is 90km/h (55mph); in towns, it's 50km/h (30mph). In case of an accident or breakdown, dial 113 (your call will probably be answered by someone who does not speak English) or the Automobile Club of Italy at 116 (where your call may be answered by an English speaker). Roadside phones, usually yellow, are placed at frequent intervals along major roads. And rest assured, an Italian driver who stops to assist you is likely to have a cell phone.

It is usually difficult (and often illegal) to park on the street in towns and cities. Look at signs carefully—parking is often restricted to residents only, or you will be required to pay for parking at a curbside machine, which will deliver a receipt (indicating the time of expiration) that you must display in full view on the dashboard. Many cities and towns have municipal parking lots and garages at the fringes of their historic centres; use these whenever possible. Florence, for instance, is ringed by parking facilities from which shuttle buses transport visitors into the centre.

Petrol is readily available (though off the autostradi many stations close for lunch from noon to 3pm). It is available in three grades: *super*, *normale*, and *senza piombo* (unleaded).

Signage on all roads is excellent. Some common terms you are likely to encounter (and these will usually be accompanied by the international symbol) are:

Curva pericolosa Deviazione Divieto di sorpasso Dangerous curve Detour (diversion) No passing (overtaking)

Divieto di sosta Lavori in corso Pericolo Rallentare Senso vietato/unico Vieto l'ingresso Zona pedonale Zona traffico limita

Some useful phrases:

Driver's license
Car registration papers
Green insurance card
Can I park here?
Are we on the right
road for...?
Fill the tank, please, with...
I've had a breakdown.
There's been an accident.

No stopping Men working (road works) Danger Slow down No entry/one-way street No entry Pedestrian zone

Limited traffic zone

Patente
Libretto di circolazione
Carte verde
Posso parcheggiare qui?
Siamo sulla strada
giusta per...?
Per favore, faccia il pieno de...
Ho avuto un guasto.
C'è stato un incidente.

Fluid measures

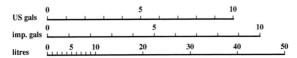

Distance

E

ELECTRIC CURRENT

220V/50Hz is standard. Visitors from other countries may require an adapter (*una presa complementare*), and those from North America will need a converter as well. Better hotels often have special outlets for some North American appliances.

EMBASSIES and CONSULATES

These offices are the places to go if you lose your passport, are embroiled in police or other bureaucratic dealings, or are otherwise in need of assistance. The American Consulate in Florence is at Lungarno Amerigo Vespucci 46, Tel. (055) 239 8276, and the British Consulate is at Lungarno Corsini 2, Tel. (055) 284 133. Citizens of other English-speaking countries can turn to their embassies in Rome:

Via Alessandria 215; Tel. (06) 852 721 Australia Via G. B. de Rossi 27; Tel. (06) 445 981 Canada Via Zara 28: Tel. (06) 440 2928 New Zealand

Republic of Ireland Largo del Nazareno 3; Tel. (06) 697 9121 Via Tanaro 14; Tel. (06) 841 9794. South Africa

EMERGENCIES

The general emergency number is 113. Call 112 for the carabinieri (national police), 115 for the fire department, and 118 for an ambulance.

Per favore, può fare me una Please, can you place an emergency call for me to the...? telefonata d'emergenza...?

alla polizia Police. Al fuoco! Fire! fire brigade ai pompieri ambulanza ambulance al'ospedale hospital

GAY and LESBIAN TRAVELLERS

Italians (especially those here in the north) tend to accept homosexuality but, still rooted in family traditions, may not tolerate public displays of affection. On the other hand, this is a country where friends of the same sex often walk down the street arm in arm, so there's quite a bit of latitude about what constitutes such a display. Florence is one of the most gay-friendly cities in Italy, and Elba one of the most popular resorts with gays and lesbians; the latter has some spiaggi gay (gay beaches). Azione Gay e Lesbica, Italy's national gay organisation, has an office in Florence at Via Manara 12, Tel. (055) 671 298; you can

check out their website, which has listings of gay bars, bookstores, and other resources throughout Italy, at http://www.azionegayelesbica.it.

GETTING THERE

By air. If you are travelling from North America, Australia, New Zealand, or South Africa, you will fly into Rome's Leonardo da Vinci Airport and make air or land connections from there. (Milan is another option, but Rome is closer and the connection between international and domestic flights in Milan requires a change of airports, a time-consuming process.) Travellers from Great Britain can fly into Pisa or Florence. Alitalia, Italy's national airline, has service to Rome from New York, Newark, Boston, Miami, Chicago, and Los Angeles. with daily flights to and from most of these cities. Delta and TWA are among the major US carriers that fly into and out of Rome, with nonstop service to and from New York and, depending on the season, some other US cities. British Airways offers daily flights from London and other British cities to Rome, as well as less frequent flights from London to Pisa; Alitalia also flies from London to Rome. Air Canada provides service to Rome from major Canadian cities. and Oantas and Alitalia both run several nonstops a week to and from Sydney, with Qantas providing service from Melbourne and several other cities in Australia and New Zealand. South African Airways and Alitalia provide frequent service between Johannesburg and Rome.

When planning a trip to Italy, remember that, in airline terminology, high season (when rates are highest) is from June into early September; shoulder season, when prices are substantially lower than they are in high season, is from April through May and early or mid-September through October, and low season is November through March—with the notable exceptions of Christmas and Easter, when fares return to high-season levels. To give you an idea of how much fares can fluctuate within these seasons, a round-trip ticket from New York to Rome can be \$1000 or more in high season and less than \$300 in low season.

Budget options. In general, the most economical fares are APEX, which usually require an advance purchase of 14 to 21 days and are valid for stays of 7 to 30 days; fares are almost always lower for midweek departures. The lowest fares are usually available in the slowest travel times—extremely low fares are often available in early Novem-

ber, early December, and January through March; at these times, for example, many airlines offer air and hotel packages, often at all-inclusive rates that are considerably less than the cost of a ticket alone in high season. An option that can sometimes save you money when travelling to Italy from outside Europe is to fly on another European national carrier to its European hub and continue on to Rome, Pisa, or Florence from there. British Airways, Scanair, KLM, and Air France often offer attractive rates on such routing—sometimes allowing a stopover in the country in which they are based—especially out of season. Many charter carriers also serve Italy, offering low fares.

By train. A sophisticated rail network links Italy with countries throughout Europe. If you are adding a tour of Tuscany and Umbria to a sojourn elsewhere in Europe, you will find that many international trains make stops in Florence and Pisa. Eurostar service under the Channel has considerably decreased travel times from London to Italy; on the most direct route, you can make the 3-hour trip to Paris and then connect to an overnight train to Pisa or Florence (a trip of 8 to 10 hours). Another option is to connect in Paris to one of the new high-speed trains that whisk you to Milan in just under seven hours, and from there make connections to Florence (another three hours). For schedules and general information, contact the Italian State Tourist Board (see page 126) or CIT, which is the travel arm of Ferrovia della Stato (FS, the Italian state railway) and which has an informative website at: www.cit-tours.com. Another good source of information is Rail Europe, www.raileurope.com.

Budget options. If you are planning extensive rail travel in Europe, you may want to consider one of the many available types of rail passes. A Eurail pass (available only to travellers who do not reside in an EU country) allows unlimited travel through 17 European countries (the UK is a notable exception) for periods of 15 to 90 days on consecutive passes, and 10 to 15 days within a two-month period on the Flex pass. Other variations sometimes combine two or more countries, such as France and Italy. But if you are simply interested in getting from one city to another, it may be considerably less expensive to purchase a one-way ticket. For information, in the US contact Rail Europe (see paragraph above). Europeans can travel at reduced rates with a Rail Europ S card for senior citizens, a Rail

Europ F card for families, and an Inter-Rail card for those under age 26; inquire at train stations for more information.

By car. Italy is connected to the continent by an excellent road network. Even the trip to and from the UK has become much easier with the launch of the high-speed rail link under the English Channel that connects Folkstone with Calais (details from www.eurotunnel.com). Cars and passengers are whisked through the tunnel in 35 minutes; service runs around the clock with departures every half hour and sometimes more frequently.

GUIDES and TOURS (guida, giro)

Agencies specializing in tours of every corner of Tuscany and Umbria abound. Tourist offices, local travel agencies, and hotels can provide lists. A good source in Florence is Florence Guides, an organisation of professional tourist guides authorised by the Florence city council. The group includes many native, English-speaking Florentines who delight in introducing visitors to their city. Details of their tours can be found at the website, www.florenceguides.com.

The many tours that bring visitors to the regions include some interesting educational opportunities. Some language programs that welcome students of all ages for courses two weeks to several months long are the British Institute of Florence, Piazza Strozzi 2, 50123 Firenze, Tel. (055) 284 031 (www.britishinstitute.it), and the Università per Stranieri, Piazza Fortebraccio 4, 06122 Perugia, Tel. (075) 57 461 (www.unistrapg.it). A good source of information on learning vacations is the Shaw Guides, available on the World Wide Web at http://www.shawguides.com.

We'd like an English-speaking Ho bisogno di un guida guide. Ho bisogno di un guida d'inglese.

HEALTH and MEDICAL CARE

The good news is that, in terms of health, Tuscany and Umbria are among the safest places on earth to travel. You are not likely to encounter any unusual strains of infectious ailments, and health care is good. The bad news is, if you do become ill, many insurance policies (including the US Medicare system) will not cover treatment in Italy. However, travellers from other EU countries are covered by their national policies, and North Americans who are not covered when travelling abroad can purchase additional travel insurance (check with your insurance carrier about this optional coverage). You will often be asked to pay for treatment up front, so keep all receipts for reimbursement. A good source for information on health concerns when travelling is the International Association for Medical Assistance to Travellers (IAMAT). In the US, contact IAMAT at 417 Center Street, Lewiston, NY 14092, Tel. (716) 754-4883, and in Canada at 40 Regal Road, Guelph, Ontario N1K 1B5, Tel. (519) 836-0102.

Pharmacies (farmacie) have green crosses above the entrance; in each town, one pharmacy stays open late and on Sundays on a rotating basis, and the after-hour locations for the month are posted in all pharmacies. The pharmacy in the Santa Maria Novella train station

in Florence is always open late.

Water is considered safe to drink, though Italians prefer bottled water, which is very inexpensive. Travellers from abroad may want to follow their example: water pipes in many cities and towns are very old and impurities may leach in, and spring-fed systems in the country can sometimes be contaminated by animals.

I need a doctor/dentist.
I have a stomach ache.
I have a fever.
I have a sunstroke.

Ho bisogno di un medico/dentista. Ho il mal di stomaco.

Ho il mai di stomaco

Ho un colpo di sole.

l

LANGUAGE

Italians, especially Tuscans and Umbrians, respect their language and expect foreigners to appreciate its richness and beauty as well. Many, especially in Florence, speak English, but then again, many do not. English-speaking or not, they will applaud your efforts for trying to speak even a few words—and unlike their neighbours in France, will not scoff at your errors. Some basic tips:

A as in father, E as in egg; I as e in eat; O as in ostracise; U as oo in mood

Tuscany quando-when esseresons lang come star - how are you give ho - how

C's before E's and I's are pronounced CH, as in *church*. Otherwise, C and CH are pronounced as K, as in *cane*.

G's before E's and I's are pronounced as J, as in gin. Before other let-

ters, G is hard, as in gun.

Most feminine words end in a, plural e, and most masculine words end in o, plural i. La is the feminine article, il the masculine.

Some basic words and phrases

Good morning/good afternoon	Buon giorno	Bwon JOARno
Please	Per favore	Pair fahVOAray
Thank you	Grazie	GRAAseeay
Yes/no	Si/no	See/no
Excuse me	Mi scusi	Mi skoozee
Where is?	Dovè?	DoaVAI?
I don't understand.	Non capisco.	Noan kahpeeskoa.
Open	Aperto	AhPAIRtoe
Closed	Chiuso	KeeOOso
I'd like	Vorrei	VorRAIee

Numbers

uno	one	sette	seven
due	two	otto	eight
tre	three	nove	nine
quattro	four	dieci	ten
cinque	five	cento	hundred
sei	six		

Days of the week

Monday	Lunedi	Tuesday	Martedi
Wednesday	Mercoledi	Thursday	Giovedi
Friday	Venerdi	Saturday	Sabato
Sunday	Domenica		

M

MONEY MATTERS

Currency. Italy's monetary unit is the *Euro* (abbreviated €), which is divided into 100 *cents*. Banknotes are available in denominations

of 500, 200, 100, 50, 20, 10 and 5 Euros. There are coins for 2 and 1 Euro, and for 50, 20, 10, 5, 2 and 1 cent.

Currency exchanges. Banking hours are generally 8:30am to 1pm and 3 to 4pm, with many, many exceptions. Major banks in cities and at least one bank in most towns have currency exchanges. Post offices and train stations also usually have currency-exchange windows. You will often come across conversion machines in which you deposit bills of other major currencies and are given lire in exchange.

Traveller's checks and credit cards. Both are widely accepted, though most establishments give an unfavourable exchange rate on traveller's checks; you are better off cashing them at a currency exchange and paying in cash. Visa and MasterCard are the most widely accepted credit cards, and many establishments do not take American Express cards. Incidentally, the main American Express office in Florence, where you can cash traveller's checks without paying a commission fee, is at Via Dante Alghieri 22r; Tel. (055) 50 981.

ATM machines. These technological advances make travelling much easier. Using your bank card, you can withdraw money all over the world in the local currency, usually at exchange rates that are more favourable than those you would receive at a currency exchange. ATM machines, which offer instructions in English, sprout from the sides of medieval buildings and elsewhere in almost every town throughout Tuscany and Umbria. If for some reason a machine does not work, try another machine—no matter what message pops up on the screen, chances are the problem is a temporary glitch with phone lines or the bank's computer system and not with your card.

OPENING TIMES

Big news on openings: many museums in Florence and elsewhere now remain open continuously throughout the day, or at least longer than they once did, on fairly straightforward schedules (unlike the

one-hour-every-other-Wednesday timetable of yesteryear), and even into the evening (see hours for Florence museums and churches on page 34). Shops tend to close in midday for two or more hours. In general, hours are:

Banks: 8:30am-1pm and 3-4pm, Monday through Friday

Bars: 7am-11pm, often as late as 2am (remember, bars in Italy serve much more than alcohol)

Churches: Very early in the morning until noon or 12:30 and from 3 to 7 or 8pm (they are open seven days, but are often closed to all but mass-goers on Sunday)

Museums: six days a week, often from 10am-6pm, or the same hours with a midday closing from 12:30-3pm

Restaurants: Noon–2:30 or 3pm for lunch, 7 or 7:30pm–10 or 10:30pm for dinner (they usually close one day a week)

Shops: 8:30 or 9am-1pm and 3:30 or 4pm-7 or 8pm.

P

POLICE (polizia)

There are three kinds of police in Italy: *vigili urbani*, who deal with petty crime, traffic, parking, and other day-to-day matters (including the concerns of tourists asking for directions); *carabinieri*, the highly trained national force who handle serious crime and civilian unrest, protect government figures, and perform other high-profile tasks; and *polizia stradale*, who patrol the roadways. Any of these forces may answer a 113 emergency call, though the carabieneri have their own emergency number, 112.

Where's the nearest police station?

Dovè il più vicino posto di polizia?

POST OFFICES

City post offices are generally open from 8am to 7pm Monday through Friday, and 8:15am to noon on Saturday; in smaller towns they sometimes close from noon to 3pm. It costs $\{0.70\}$ to mail a postcard or letter weighing up to 20 grams to the US, Australia, New

Zealand, or South Africa, and €0.45 to the UK and Republic of Ireland. Whatever you send and however long you travel, chances are you will be back home long before it reaches its destination. If you want something to arrive with alacrity, consider using FedEx or another international delivery service.

Many post offices also send faxes, exchange money, and provide public telephones.

I would like a stamp for this letter/postcard. Desidero un francobollo per questa lettera/cartolina. Via aerea

PUBLIC HOLIDAYS

Tuscany and Umbria celebrate many a good local festivals (see page 89), and all the national holidays as well. These are:

1 January New Year's Day Epiphany

(date variable) Easter Sunday and Monday

25 April Liberation Day 1 May Labour Day

15 August Ferragosto and Assumption Day

1 November All Saints Day

8 December Day of the Immaculate Conception

25 December Christmas

PUBLIC TRANSPORT

An extensive network of public transport makes it easy to move between major cities and towns in Tuscany and Umbria without a car, though having your own transport makes it much easier to visit the delightful rustic settings for which the regions are famous. Tourist offices usually provide train and bus schedules and fare information; in fact, if you explain where you want to go and when, the staff will usually look up times for you. Schedules are posted prominently at train stations. When travelling by train, you must stamp your ticket in one of the machines on the platform before boarding the train; you will be fined if you don't.

Florence, Perugia, Siena, Pisa, and other cities in Tuscany and Umbria (and even many small towns as well) have excellent bus systems. Tickets can be purchased at newsstands and generally cost around €1. You must stamp your ticket in one of the machines when you board the bus; failure to do so can result in a hefty fine.

Budget options. A good option, especially for families and groups, is the Italian kilometric ticket (*Biglietto Chilometrico*), which you can buy at most train stations. This pass is good for 3,000 km (1,864 miles) of travel—but total travel can not exceed 20 trips and must be completed within two months. Up to five people can be included on a single pass, with miles deducted for each person per trip. (So if five people make a journey of 100 km/62 miles, 500 km/311 miles is deducted from the pass.) The cost is €100 for second-class travel, which represents a savings of up to 30 percent over standard fares.

When is the next bus/train to...? One way Round trip First/second class What's the fare to...? Quando parte il prossimo autobus/treno per...? Andata Andata e ritorno Prima/seconda classe Qual è la tariffa per...?

T

TELEPHONE (telefono)

Public phones in Italy are orange, located all over cities and towns, and take coins (10-, 20, and 50-cent) or phone cards (scheda telefonica), available at tobacco shops for $\[\in \]$ 5 or $\[\in \]$ 25. Local calls cost $\[\in \]$ 0.10. To use these phones (which tend to emit an intimidating series of beeps at unexpected times) pick up the receiver, then insert the money or the phone card (very important: phone cards do not work until you rip off the tabbed corner). You will not hear a dial tone: simply dial, and the number you are dialing will appear in a digital display window.

All Italian city codes now begin with 0—so a Florence number now begins 055, not 55: you must precede the number with a city code when dialing from one city to another within Italy; however,

you do not dial a city code when calling within that city (for example, drop the 055 when calling from a number in Florence to another number in Florence). To call internationally, you must first dial 00, then the country code (1 for the US and Canada, 44 for the UK, 353 for the Republic of Ireland, 61 for Australia, 64 for New Zealand, 27 for South Africa), then the city or area code, then the number.

Hotels slap very large surcharges on long-distance calls. One way around this is to use a telephone calling card and bill all cards to that. Your calling card company can supply the access code you must dial to reach its system; simply dial the code, and an English-speaking operator will come on to assist you or you can follow a series of English-language prompts.

TIME ZONES

Italy is one hour ahead of Greenwich Mean Time (GMT) in winter, which places it one hour ahead of London, six hours ahead of New York, nine hours ahead of Los Angeles, one hour behind Johannesburg, eight hours behind Sydney, and ten hours behind Auckland. Italy switches to daylight saving time in April, when it is two hours ahead of GMT, and reverts to standard time in October.

TIPPING

A service charge of 15 percent is added to most restaurant bills, but even so it is nice to leave a little extra for good service—the amount depends on the total amount of the bill and the quality of the service, but anywhere from small change to €2 is the norm, more for exceptional service. Tip bellhops €1 per bag. To tip a taxi driver, simply round up the total to the nearest euro and add one more.

TOILETS (gabinetto)

Public restrooms can be hard to find, and when you do locate one, you usually have to pay to use it. Facilities in train stations often are not well maintained, and the toilets are "Turkish" (a basin imbedded in the floor, requiring logistics to which many travellers may not be accustomed). For the price of a coffee or a mineral water you can use the restroom in a bar—your best option. The gents' restroom is designated by *uomini* or *signori*, the ladies' by *donne* or *signore*.

Is it possible to use the bathroom? Where are the toilets?

Posso usare il bagno? Dove sono i gabinetti?

TOURIST INFORMATION OFFICES

The place to go first for information is one of the offices of the Italian National Tourist Office (ENIT) in your home country. They can probably supply listings of accommodations throughout Tuscany and Umbria, as well as a wealth of other information. Locations are:

Canada: 175 Bloor Street East, Suite 907 South Tower, Toronto, Ontario M4W 3R8; Tel. (416) 925 4882; fax (416) 925 3870; brochure hotline (416) 925 3870.

UK: 1 Princes Street, London W1R 8AY; Tel. (020) 7408 1254; fax (020) 7493 6695

US: 630 Fifth Avenue, Suite 1565, New York, NY 10011; Tel. (212) 245-4822; fax (212) 586-9249

500 N. Michigan Avenue, Chicago, IL 60611; Tel. (312) 644-0996; fax (312) 644-3019

12400 Wilshire Boulevard, Suite 550, Los Angeles, CA 90025; Tel. (310) 820-1898; fax (310) 820-6357

Italy: Tourist offices in Italy can provide more detailed information. Some good sources are the regional tourist offices. For Tuscany: APT, Via Manzoni 16, 50100 Firenze; Tel. (055) 23 320; fax (055) 234 6286. For Umbria: Ufficio Promozione Turistica, Corso Vannucci 30, 06100 Perugia; Tel. (075) 50 41; fax (075) 504 2483

In addition, many towns have tourist offices, which often can help arrange house and apartment rentals; they can also arrange entry to local events and provide detailed information that often is not available from tourist offices abroad or from regional tourist offices. If you know in advance which cities and towns in Tuscany and Umbria you will be visiting, you may want to write ahead for an information packet or to obtain specific information. The regional tourist offices can provide a complete list of local tourist offices. Addresses of some tourist offices (Informazioni Turistica) in often-visited towns are:

Piazza del Comune 12, 06081 Assisi Via Cavour 1r, 50122 Firenze Piazzale Verdi, 55100 Lucca Via Ricci 9, 53045 Montepulciano Piazza Duomo 24, 05018 Orvieto Piazza IV Novembre 3, 06100 Perugia Piazza Duomo 1, 53037 San Gimignano Piazza del Campo 56, 53100 Siena Piazza della Liberta 7, 06049 Spoleto Via Giusto Turazza 2, 56048 Volterra

WEIGHTS and MEASURES

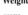

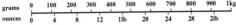

Temperature

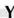

YOUTH HOSTELS

There are hostels in Florence, Perugia, Lucca, and some other cities and towns in Tuscany and Umbria. The Hosteling International Italian affiliate is Associazione Italiana Alberghi per la Gioventù (AIG), which can provide a list of Italian hostels and will book space free of charge. For more information, contact AIG at Via Cavour 44, 00184 Roma; Tel. (06) 487 1152; fax (06) 488 0492; e-mail aig@uni.net; website http://www.ostellionline.com.

Recommended Hotels

One of the pleasures of travelling in Tuscany and Umbria is enjoying some of the excellent lodgings for which the regions, especially Tuscany, are known. These range from luxurious villas to modest country retreats to old-fashioned in-town hotels. Our selective list of hotels below includes those that have a good amount of character, are well located, provide excellent value for the price, or in some other way are above the ordinary. We welcome your contributions on lodgings that you particularly enjoy.

Reservations are essential almost anywhere in the regions from May through September, and are highly recommended at other times, especially around European holidays—Tuscany and Umbria are popular with Italians

and travellers from every corner of the world.

As a basic indication of what you can expect to pay, we use the euro symbol below to indicate prices for a double room with bath, including breakfast—but remember that prices may vary with the season. For additional hotels in Florence, consult the *Berlitz Florence Pocket Guide*.

€€€€€ over 200 euros €€€€ 140–200 euros €€€ 85–140 euros €€ 50–85 euros below 50 euros

TUSCANY

Florence

Il Guelfo Bianco €€€€ Via Cavour 29, 50129 Firenze; Tel. (055) 288 330; fax (055) 295 203. A recent cellar-to-rooftop renovation has rendered the décor here more or less contemporary, giving the premises the look of a very comfortable big-city establishment. Enough of the original detailing (such as beamed ceilings) remains to remind you that this efficiently run hotel, located on a busy thoroughfare between the Duomo and the Piazza San Marco, occupies a 15th-century palace. 29 rooms. Major credit cards.

Hotel Monna Lisa €€€€€ Borgo Pinti 27, 50121 Firenze; Tel. (055) 247 9751; fax (055) 247 9755. The best rooms in this elegant 14th-century palazzo face the pretty courtyard. Though terra-cotta floors and painted ceilings embellish rooms throughout, those facing the street can be quite noisy. The public sitting rooms, decorated with original works of art and antiques, are especially welcoming. Bar. 34 rooms. Major credit cards.

Nuova Italia €€€ Via Faenza 26, 50123 Firenze; Tel. (055) 268 430; fax (055) 210 491. One of the nicer hotels near the train station, this modern establishment has such amenities as double-paned windows (a blessing in noisy Florence) and airconditioning. Rooms are pleasantly contemporary, and the welcome is always gracious. 20 rooms. Major credit cards.

Hotel Beacci Tornabuoni €€€€ Via Tornabuoni 3, 50123 Firenze; Tel. (055) 212 645; fax (055) 283 594. This lovely, atmospheric 80-year-old hotel near the Arno has the air of a well-heeled pensione, though it is a well-run, full-service hotel. Public areas include a reading room organised around a large fireplace, and the guest rooms are furnished with comfortable old pieces that look as though they have been passed down through the generations. Some of the rooms afford views over tile rooftops to the hills. Bar and restaurant. 28 rooms. Major credit cards.

Arezzo

Continentale €€€ Piazza Guido Monaco 7, 52100 Arezzo; Tel. (0575) 20 251; fax (0575) 350 485. Arezzo is a pleasant place to stop for a night, perhaps on a swing through southern Tuscany on the way to Umbria. The Continentale is definitely the choice place to stay, with a central location close to the train station and the major attractions of the old city. Rooms have been refurbished in bright, cheerful contemporary decor, and there's a pleasant rooftop terrace. Restaurant. 73 rooms. Major credit cards.

Cortona

San Michele €€€ Via Guelfa 15, 52044 Cortona; Tel. (0575) 604 348; fax (0575) 630 147. Lovely, medieval Cortona

deserves a hotel like this, occupying a 15th-century palazzo and providing welcoming lodging of the vaulted-ceiling and exposed-timber variety. The best room in the house commands a bird's-eye view of the town and valley below from a tower. 40 rooms. Major credit cards.

Fiesole

Pensione Bencista €€€ Via Benedetto da Maiano 4, 50014 Fiesole; Tel. and fax (055) 59 163. Just down the hill from the Villa San Michele (below) this lovely pensione offers the same views and the same refreshing breezes at a fraction of the cost, and also provides a delightful en famile ambiance. You will probably feel you are in someone's villa, which you are; the building is from the 14th century and has a pretty garden and big, rambling guest rooms filled with antiques and other comfortable furnishings. Rates include breakfast and either lunch or dinner. 44 rooms. Cash only.

Villa San Michele €€€€€ Via Doccia 4, 50014 Fiesole; Tel. (055) 59 451; fax (055) 598 734. You may feel like one of the Medici when staying in this luxurious 15th-century villa, with a facade designed by Michelangelo, high in the hills above Florence. While such amenities as a heated swimming pool, luxuriant gardens, and princely guest rooms come at a price that can make a dent in the largest coffers, a stay here is an extraordinary experience. 26 rooms. Major credit cards.

Lucca

La Luna €€€ Via Filungo-Corte Compagni 12, 55100 Lucca; Tel. (0583) 493 634; fax (0583) 490 021. Two renovated wings of a centuries-old building are the setting for this family-run hotel. Most rooms face a courtyard and are quiet, with pleasant if bland contemporary furnishings—a few still retain the character of days gone by. Parking lot for guests. 29 rooms. Major credit cards.

Montepulciano

II Marzocco €€€ Piazza Savonarola 18, 53045 Montepulciano; Tel. (0578) 757 262; fax (0578) 757 530. You may think

you've stumbled into the Italy of years gone by when you enter this old-fashioned hotel on a medieval piazza inside the town walls. The building is 16th century, but most of the furnishings in the downstairs parlors, billiard room, and guest rooms are from the 19th century. The choicest rooms are those with terraces overlooking the countryside. 16 rooms. Major credit cards.

Pisa

Royal Victoria €€€ Lungarno Pacinotti 12, 56100 Pisa; Tel. (050) 940 111; fax (050) 940 180. Everything about this comfortable old hotel reeks of character, from an Arno-side location to the antiques-filled public rooms to the idiosyncratic guest rooms, each of which seems to have acquired its own décor over the years. Some are furnished with heavy 19th-century pieces, some are frescoed, some have a 1920s look. 48 rooms. Major credit cards.

Prato

Flora €€€ Via Cairoli 31, 50047 Prato; Tel. (0574) 33 521; fax (0574) 400 289. Prato is an excellent alternative if you can't find a hotel in Florence, and is a nice place in its own right. The Flora is centrally located and very pleasant, with contemporary-styled rooms and amenities that include in-room VCRs, air-conditioning, and a rooftop terrace where breakfast is served in good weather. 31 rooms. Major credit cards.

San Gimignano

La Cisterna €€€ Piazza della Cisterna 24, 53037 San Gimignano; Tel. (0577) 940 328; fax (0577) 942 080. One of San Gimignano's most atmospheric inns occupies the lower portions of a couple of 14th-century towers and faces a charming piazza. Many rooms, which are plainly but tastefully furnished, have views across tile rooftops to the countryside; others look onto the town's medieval lanes. 49 rooms. Major credit cards.

Leon Bianco €€€ *Piazza della Cisterna 13, 53037 San Gimignano; Tel. (0577) 941 294; fax (0577) 942 123.* Rivaling La Cisterna (above) for charm, this pleasant inn also occupies a centuries-old building, this one a palazzo, and faces the same

lovely square as its neighbour. Here, too, rooms are pleasant and cozy, and most afford alluring vistas of the town or countryside. 25 rooms. Major credit cards.

Siena

Antica Torre €€€ Via Fieravecchia 7, 53100 Siena; Tel. and fax (0577) 222 255. A 17th-century tower in a quiet corner of the city (but a short walk from the centre) is the setting for this charming and friendly hotel. Guest rooms are small but tastefully decorated with handsome old pieces, and are reached by an enchanting stone staircase. Reserve well in advance. 8 rooms. Major credit cards.

Duomo €€€ Via Stalloreggi 38, 53100 Siena; Tel. (0577) 289 088; fax (0577) 43 043. Location is the main attraction here. On the top floor of a centuries-old building near the Campo and the church from which it takes its name, the Duomo is a perfect base from which to enjoy this elegant city. The upper-floor setting affords stunning views of the city's towers and countryside. Rooms are perfectly pleasant, with handsome contemporary furnishings, and some have balconies. 23 rooms. Major credit cards.

Volterra

San Lino €€€ Via San Lino 26, 56048 Volterra; Tel. (0588) 85 250; fax (0588) 80 620. Housed in a 13th-century convent, this hotel offers many up-to-date comforts that include chic contemporary furnishings, air-conditioning, minibars, and a swimming pool—all this, plus a nice location within the town walls. Beware, though, that some rooms, often used for groups, are not as well fitted out. 43 rooms. Major credit cards.

UMBRIA

Assisi

Subasio €€€ Via Frate Elia 2, 06081 Assisi; Tel. (075) 812 206; fax (075) 816 691. Perched on the hillside next to the Basilica of St. Francis, this converted monastery couldn't be more conveniently located. Many of the rooms (you should

request one of them) hang over the valley below and have small, view-affording terraces. The views from others, which face toward the basilica, are also inspiring; all are plainly but pleasantly decorated with homey, old-fashioned pieces. 68 rooms. Major credit cards.

Umbra €€€ Vicolo degli Archi 6, 06081 Assisi; Tel. (075) 812 240; fax (075) 813 653. You may think you've found the getaway of your dreams in this lovely 13th-century palazzo-cum-hotel. There's a wonderful, old-fashioned feeling throughout, from the medieval vaults and brickwork to the 19th-to early-20th-century pieces in the salons and guest rooms. Many rooms are suites, with sitting areas near windows providing views of tile rooftops and the valley below. A grassy garden adjoins the superb restaurant (see page 143). Panoramic rooftop terrace. 25 rooms. Major credit cards.

Gubbio

Bosone Palace €€-€€€ Via XX Settembre 22, 06024 Gubbio; Tel. (075) 922 0688; fax (075) 922 0552. Gubbio's best hotel may well provide the most atmospheric lodgings in Umbria, housed as it is in a 14th-century palazzo. Many of the spacious guest rooms are frescoed, and several suites are tastefully furnished with reproduction Renaissance pieces. 25 rooms. Major credit cards.

Gattapone €-€€ Via Ansidei 6, 06024 Gubbio; Tel. (075) 927 2489; fax (075) 927 2417. A recent renovation has left only the timbered ceilings and other architectural elements to remind you that these surroundings in the centre of town have seen many centuries pass. Furnishings, baths, and other facilities are completely up to date and very comfortable, and the views over the rooftops are enchanting. Wheelchair access. 18 rooms. Major credit cards.

Orvieto

La Badia €€€€€ Localita La Badia, 05018 Orvieto (3km/2 miles south of Orvieto); Tel. (0763) 301 959; fax (0763) 305 396. A 13th-century former monastery offers one of Umbria's most cherished country retreats. Rooms and suites vary in size considerably

but all are tasteful, with stone walls and beams and many other charming features. The views from here are up to graceful Orvieto sitting atop its bluff, and you can enjoy it from a lawn chair on the grounds, which contain a pool and tennis courts and are very well maintained. Restaurant. 19 rooms. Major credit cards.

Virgilio € Piazza del Duomo 5–6, 05018 Orvieto; Tel. (0763) 341 882; fax (0763) 343 797. If you are lucky enough to get a room with a view of Orvieto's cathedral (one of the most magnificent structures in a country with no shortage of them) you may never leave your room. When you do, you will find yourself in the centre of this sophisticated little town. Even rooms without a view are quite a value, with comfortable furnishings. 13 rooms. Major credit cards.

Perugia

Priori €€ Via dei Priori, 01623 Perugia; Tel. (075) 572 3378; fax (075) 572 3213. This elegant but affordable hotel enjoys the kind of location that hill towns, even overgrown ones like Perugia, are so good at providing. It's in the centre of the city but perched on the hill; as a result, some of the comfortably furnished, contemporary-style rooms overlook the historic church of San Filippo Neri, and others look out to the valley below. There is a huge terrace with panoramic views; weather permitting, this is where breakfast (included in the rates) is served. 55 rooms. Major credit cards.

Spoleto

Aurora €€ Via Apollinare 3, 06049 Spoleto; Tel. (0743) 220 315; fax (0743) 221 885. In a quiet (and rest-assuring) courtyard but in the centre of town near the Corso Mazzini, this small hotel offers a great deal of comfort and some amount of style for the price. Guest rooms are in various states of refurbishment, with some smartly done in contemporary furnishings and others of a well-kept 1970s vintage. 15 rooms. Major credit cards.

Recommended Restaurants

Following is the Berlitz choice of restaurants in Tuscany and Umbria. We've tried to include places that best capture the experience of dining in these regions while covering a range of prices. There are many, many excellent establishments we have not had room to include here, and we'd be pleased to hear from you about any you think we should add.

Unless indicated otherwise, these restaurants are open for lunch and dinner. As a general rule, this means they serve from noon or 12:30pm to 2:30 or 3pm, and from 7

or 7:30pm to 10 or 10:30pm.

As is the case throughout Italy, a service charge (servizio) of 15 percent is usually added to the bill. If not, leave a tip of that amount. When a servizio is included, you may want to leave something extra, especially if the service has been attentive and friendly—as it usually is. A euro or two is appropriate, more if the experience warrants it. There will also normally be a pane e coperto (bread and cover) charge of €1-3.

As a basic guide to what you can expect to pay, we have used the following symbols to give an indication of the price of a three-course meal, excluding wine. For additional restaurants in Florence, see the *Berlitz Florence Pocket Guide*.

€€€€ over 40 euros **€€€** 25–40 euros **€€** 15–25 euros **€** below 15 euros

FLORENCE

Acqua al Due €€ Via della Vigna Vecchia 40r; Tel. (055) 284 170. Open daily. Lunch and dinner weekends, dinner only weekdays. This is a wonderful place to sample Florentine specialities, since many of the meals are served as assaggi, or sampling plates. The assaggio di primi is a meal in itself, with five different kinds of pastas that change daily. It's popular with locals and

tourists, and the latter don't seem to mind that there is no menu. Open late. Major credit cards.

La Capannina di Sante €€€-€€€ Piazza Ravenna; Tel. (055) 688 345. Closed Sunday. What is reputed to be best fish restaurant in Florence occupies unpretentious surroundings on the banks of the Arno, with a pleasant terrace in warm weather. The offerings remind you that Tuscany touches the sea and include some wonderful seafood risottos along with a very popular grigliata mista and fritta mista (platters of either grilled or fried seafood). Major credit cards.

Coco Lezzone €€ Via del Parioncino 26r; Tel. (055) 287 178. Closed Sunday. This small trattoria near the church of Santa Trinfta has a loyal following among Florentines, who don't seem to mind rubbing elbows at the long communal tables to enjoy the kitchen's simple but superb offerings. These often incorporate fresh mushrooms (funghi procini), which appear atop pastas or with simple preparations of chops and cutlets (scallopine); in autumn, truffles from Umbria are sometimes served. Cash only.

Enoteca Pinchiorri €€€€ Via Ghibellina 87; Tel. (055) 242 777. Closed Sunday. Elegant, formal, and expensive, this restaurant receives some of Italy's highest marks for its culinary achievements as well as for the surroundings—a sumptuous Renaissance palace with frescoed ceilings. Nouvelle Tuscan cuisine. Major credit cards.

La Maremmana €€ Via dei Macci 77/r; Tel. (055) 241 226. Closed Sunday. Another popular trattoria, this one near Santa Croce, welcomes a boisterous mix of students, travellers, and business people to its long communal tables. The fixed-price menu offers one of the house's simple pasta dishes and a meat course at especially good value. Major credit cards.

Le Mossacce € *Via del Proconsolo 55r; Tel. (055) 294 361.* Closed weekends. This tiny restaurant near the Duomo serves Florentine favorites and prepares them with flair. You may want to try the beefsteak for which the city is famous, because the

choicest grades are served here. Only a few pasta dishes are served daily; they are always made with ingredients fresh from the market that morning. Major credit cards.

Sostanza (a.k.a. Il Troia) €€ Via del Porcellana 25r; Tel. (055) 212 691. Closed weekends. Florence's oldest restaurant is to be enjoyed as much for the experience of sharing a communal table with travellers from all over the world as for its excellent, straightforward food. The nickname is a giveaway for what to expect—troia means trough, and there is a lot of good-natured fun in watching so many happy diners digging into such hearty Tuscan favorites as ribollita and grilled chops. Major credit cards.

Trattoria Za-Za €€ *Piazza del Mercato Centrale 26r; Tel. (055) 215 411.* Closed Sunday. The walls of this typical Florentine eatery, just across from Florence's lively food market, are lined with Chianti bottles and photos of famous and not-so-famous past and present patrons. With fresh ingredients so near at hand, the food is fresh and delicious. *Trippa* (tripe) is one of the excellent and typically Florentine dishes on the menu. Major credit cards.

TUSCANY OUTSIDE OF FLORENCE Arezzo

Buca di San Francesco €€ Piazza San Francesco 1; Tel. (0575) 23 271. Closed Thursday, Monday dinner, and July. Buca means "cellar," and this atmospheric restaurant, an Arezzo institution, owes much of its charm and fame to the atmospheric frescoed rooms in the cellars of the centuries-old buildings it occupies. A good way to sample the offerings of the kitchen is with the saporita di Bonconte, a sort of mixed grill featuring a selection of nicely prepared meats: some grilled, some roasted, some fried. Major credit cards.

Le Tastevin €€ Via de Cenci 9; Tel. (0575) 28 304. Closed Monday. The eclectic décor here includes two warm-hued rooms with a tiled-floor, rustic Tuscan look and a contemporary barroom where the owner displays his musical talents with piano renditions of American classics you probably won't mind listen-

ing to. Even if you do, you will soon be diverted by the impressive house specials that include risotto and pasta infused with a cream-of-truffle sauce. Major credit cards.

Cortona

La Grotta €€ Piazza Baldelli 3; Tel. (0575) 630 271. Closed Tuesday. In summer, arrive early in order to procure one of the five or six tables next to the fountain in the little alleyway, off Cortona's main square, that leads to this homey trattoria. The stone, brick, and wood interior, on several levels, is also appealing. Wherever you sit, you may think you're in heaven when you try the house speciality, gnocchi di ricotta e spinachi. Major credit cards.

Lucca

La Buca di Sant'Antonio €€-€€€ Via della Cervia 1-5; Tel. (0583) 55 881. Closed Sunday evening and Monday. What is probably Lucca's most famous restaurant has been serving for more than 200 years, and welcomes diners in a cozy maze of intimate rooms where musical instruments and books line the walls. A speciality of the house is roast kid (capretto), often preceded by ravioli stuffed with zucchini and ricotta cheese. Major credit cards.

La Mora €€€ Via Sesto di Pesto a Moriano 1748; Tel. (0583) 406 402. Closed Wednesday. This lovely country restaurant is 10 km (6 miles) outside of Lucca, providing a nice outing between seeing the sights in this lovely city. Starters include a typical rustic Tuscan dish, minestra di farro, a soup of wheat, beans, and other vegetables. All of the pastas are made fresh daily on the premises, and meats are grilled over a wood fire. Major credit cards.

Montepulciano

Ristorante il Cantuccio €€ Via d. Cantine 1-2; Tel. (0578) 757 870. Closed Monday. This friendly, welcoming restaurant is made all the more so with great expanses of brick and a roaring fire in the hearth. The menu, too, is rustic in its leaning, with a nice selection of fowl and game birds prepared on a spit, and grilled meats, all accompanied by servings of Tuscan white beans. Major credit cards.

Pienza

Dal Falco €€ Piazza Dante Alighieri 3; Tel. (0578) 748 551. Closed Friday. This relaxed trattoria, popular with residents of this lovely town, is in a modern building but steps away from the elegant Renaissance city centre. In warm weather you can dine on a pleasant terrace out front, and at other times in a somewhat contemporary dining room where decidedly old-style cuisine is served. A large selection of meat and game is grilled over an open fire. Major credit cards.

Pisa

Da Bruno €€€ Via Luigi Bianchi; Tel. (050) 560 818. Closed Tuesday. Though beamed ceilings, tiled floors, and a homey smattering of paintings on the walls lend this pleasant trattoria a rustic feel, it is not far from the city centre and an easy walk from the Duomo and its famous leaning tower. The Pisan menu includes zuppa alla pisana, a thick vegetable soup, and a nice selection of fresh fish from the nearby Mediterranean. Major credit cards.

Pistoia

Lo Storno € *Via del Lastrone 8; Tel.* (0573) 26 193. Closed Sunday and August. This small, noisy, but very cheerful restaurant has the distinction of occupying premises that have been serving food and drink for more than 600 years. In the current manifestation, only a few each of pasta and main dishes are offered, all of them delicious and, with such choices as *ribollita* (a hearty soup), rooted deep in Tuscan tradition. Cash only.

Prato

La Veranda €€ Via dell'Arco 10; Tel. (0574) 38 235. Closed Sunday. Looks are deceiving at this popular restaurant near the 13th-century Castello dell' Imperatore. The decor, with fussy pink walls and glass chandeliers, is a bit formal, especially for easygoing Tuscany. But the service is friendly, and the atmosphere is casual and welcoming to families, who enjoy a large array of antipasti and traditional Tuscan specialities. Major credit cards.

San Gimignano

Bel Soggiorno €€€ Via San Giovanni 91; Tel. (0577) 940 375. Closed Monday and January–February. One of the great pleasures of dining at this rustic, 100-year-old eatery is enjoying the panoramic view over the rooftops to the golden hills rolling away in the distance. Hearty soups and rich stews make this an excellent choice on a chilly autumn or winter evening. Major credit cards.

Le Vecchie Mura €€ Via Piandornella 15; Tel. (0577) 940 270. Closed Tuesday. A former stable with vaulted ceiling provides a cozy setting for a meal, made all the more so by handsome long tables and communal benches. In keeping with this rustic ambiance, the house speciality is *cinghiale*, the wild boar that roams the hills of Tuscany; boar meat can be savoured in the form of grilled steaks or as an ingredient in rich pasta sauces. Major credit cards.

Siena

Osteria le Logge €€€€ Via del Porrione 33; Tel. (0577) 48 013. Closed Sunday. One of Siena's most popular restaurants spills over two floors of a centuries-old house near the campo and onto a terrace for warm-weather dining. An unusual primi is a house speciality, malfatti. Main courses stick to such substantial basics as veal chops and rabbit. Major credit cards.

Tullio Al Tre Cristi €€ Vicolo di Provenzano 1; Tel. (0577) 280 608. Closed Tuesday. Though it's been a long time since this cozy trattoria served only residents of the surrounding houses, the two long rooms adorned with paintings and lined with benches retain a friendly, neighbourhood feel. In warm weather, the place to eat is the terrace. Wherever you dine, you can enjoy the wonderful assortment of crostini to start and move on to some unusual local dishes such as spaghetti alla bricole (with a simple sauce of tomato, garlic, and bread crumbs). Major credit cards.

Volterra

Etruria €€ Piazza dei Priori 6–8; Tel. (0588) 86 064. Closed Thursday. With a wonderful location on the lovely main piazza and

Recommended Restaurants

named for Volterra's early inhabitants, the Etruria is reputed to be the best restaurant in town. It lives up to this reputation with a lovely frescoed interior and an excellent kitchen that sends out a large assortment of *crostini* to begin, followed by such hefty fare as pasta with hare sauce and grilled steaks and chops. Major credit cards.

UMBRIA

Assisi

La Stalla €€ Via San Rufino Campagna 8; Tel. (075) 812 317. Closed Monday. You will have to drive to this restaurant, or make the 1½-km (one-mile) trip on foot, but after all, the countryside location is what this restaurant, housed in what was once a livestock stable, is all about. The food, much of it prepared on an open fire, matches the countrified décor with its concentration on hearty portions of grilled meats. Cash only.

Umbra €€€ Via di Archi 6; Tel. (075) 812 240. Closed Sunday and Wednesday lunch. Located in the hotel of the same name and graced with the same charm, the Umbra serves meals in an elegant, high-ceilinged room that opens onto a lovely garden for summer dining. This is an ideal setting in which to enjoy risotto laced with the truffles for which the region is noted, or one of the grilled game dishes. Major credit cards.

Gubbio

Taverna del Lupo €€€ Via Ansidei 21; Tel. (075) 927 4368. Closed Monday. A Gubbian landmark, the Lupo is immense, seating 200 diners in what remain cozy environs, and so popular there is rarely an empty table. The Umbrian specialities include lasagna with truffles. Major credit cards.

Orvieto

Le Grotte del Funaro €€ Via Ripa Serancia 41; Tel. (0763) 343 276. Closed Monday. It's difficult to know what deserves more praise here: the Umbrian cooking or the amazing location; both win the praises of both locals and tourists. Fresh-made pastas and grilled meats are often topped with truffles, and you will enjoy

them in a series of caves (*grotte*) etched out of the mountain that Orvieto crowns. Pizzas available as well. Major credit cards.

Perugia

Il Falchetto €€ Via Bartolo 20; Tel. (075) 573 1775. Closed Monday. This lively spot just off the Piazza IV Novembre occupies charming stone-walled quarters and serves excellent food at very fair prices. The homemade gnocchi, here called falchetti, are wonderful, and can be followed nicely with a selection of grilled meats. Major credit cards.

La Taverna €€€ Via delle Streghe 8; Tel. (075) 572 4128. Closed Monday. Next to Teatro Pavone, this two-level restaurant has a refined and very romantic air, with candles flickering beneath the barrel-vaulted ceilings. Truffles (tartufi) appear atop some of the pasta dishes, as do less expensive but exquisite wild mushrooms (funghi porcini). Major credit cards.

Spoleto

Il Tartufo €€€ Piazza Garibaldi 24; Tel. (0743) 40 236. Closed Wednesday. Tartufo means truffle, and in Spoleto's oldest, most renowned, and most intimate restaurant, classical music will waft over your table as your enjoy the namesake fungus in many manifestations. Atop pastas or slices of tender veal, they add an exquisite flavor and make for a memorable dining experience. Major credit cards.

Todi

Umbria €€-€€€ Via San Bonaventura 13; Tel. (075) 894 737. Closed Tuesday. Once you've eaten here, you will not doubt anyone who says that the Umbria has the best outlook in the region, or for that matter anywhere in Italy. Especially from the vine-shaded terrace, the views seem to extend to forever across those magical, undulating Umbrian hills. The interior room, with its hearth and wood-beamed ceilings, is warm and inviting, as is the cuisine. Game birds are roasted over an open fire, or you can enjoy some hearty primi that include polenta (a creamy commeal mush here laced with funghi procini or truffles). Major credit cards.

INDEX

Altar of Saint James 46 Arezzo 9, 15, 21, 68-70, 87, 99 Assisi 7-8, 12, 15, 19, 21-23, 79-80, 88-90, 101

Baptistery (Pisa) 63 Baptistery of San Giovanni 26, 29, 34 Basilica di San Francesco 79, 81

Campanile 28-29, 44, 66, 79 Campo dei Miracoli 63, 65 Camposanto cemetery 65 Casa di Dante 31, 34 Cattedrale di San Martino 62 Chiantigiana 48 church and monastery of San Marco 41

Colle di Val d'Elsa 13, 56 Collegiata 57 Cortona 70-71, 88, 90

Duomo (Florence) 26-31
Duomo (Gubbio) 79
Duomo (Livorno) 66
Duomo (Montepulciano) 72
Duomo (Orvieto) 83
Duomo (Perugia) 78
Duomo (Pienza) 73
Duomo (Pisa) 64
Duomo (Pistoia) 46
Duomo (Prato) 45
Duomo (Siena) 53
Duomo (Spoleto) 83

Elba 60, 67-68, 88, 91 Eremo delle Carceri 81

Fiesole 11, 43-45, 93

Galleria degli Uffizi 34, 37 Galleria dell'Accademia 21, 34, 39, 41

Galleria Nazionale 77 Galleria Palatina 34, 38 Giardini di Boboli 34, 39 Gubbio 12, 78-79, 86, 88-90, 93

Il Campo (Siena) 50, 53-54

Lago di Trasimeno 70-71, 91, 100 Leaning Tower of Pisa 63 Livorno 60, 64-67, 89, 91, 99 Lucca 12, 60-61, 63, 88, 90, 92

Massa Marittima 66, 88
Mercato Centrale 30, 42
Mercato Nuovo 30, 35, 86
Montalcino 12, 73-75, 103
Monte Oliveto Maggiore 74
Montecatini 47
Montepulciano 12, 71-72, 88, 90, 103
Monterchi 69-70
Monteriggioni 55-57, 93
Museo Civico 52, 59, 70, 74
Museo dell'Accademia
Etrusco 70

Museo dell'Opera del Duomo 29-30, 34, 63, 65 Museo dell Opera Metropolitana 53 Museo Guarnacci 14, 59 Museo Nazionale del Bargello 31,34

Orsanmichele 32, 34-35 Orvieto 9, 12, 83-84, 88, 93, 103 Ospedale del Ceppo 46

Palazzo Comunale 72, 74 Palazzo dei Consoli 79 Palazzo dei Priori 59, 76-78 Palazzo del Bargello 31 Palazzo Ducale 79 Palazzo Pitti 38-39 Palazzo Vecchio 34-35, 38, 41, 59,72 Palio 53-54, 90 Parco dei Termi 47 Perugia 10, 12-14, 21-22, 76-79, 81, 83, 88, 91, 93, 101 Piazza dei Priori 59, 87 Piazza del Comune 22, 80-81 Piazza del Duomo 26, 30, 56-57, 83 Piazza del Popolo 81 Piazza della Cisterna 58 Piazza della Signoria 15, 31-33, 35, 86, 102 Piazza Grande 21, 66, 68-69,

Piazza Pio II 73 Pienza 12, 72-73, 88 Pinacoteca e Museo Civico 59 Pinacoteca Nazionale 53 Pistoia 12, 46-47, 90 Ponte delle Torri 83 Ponte Vecchio 8, 11, 15, 18, 38, 86, 93 Porto Mediceo 66

Prato 12, 45-46, 88-90, 101

Rocca Maggiore 80 San Francesco basilica 23, 68, 79,81 San Gimignano 9, 11-12, 56-57, 59, 88-89, 93, 103 San Lorenzo 17, 20, 30, 34, 42-43, 86 San Michele in Foro 61-62 San Salvatore 82 Sansepolcro 69-70 Santa Croce 20, 34, 40, 86, 90,97 Santa Maria Novella 34, 41-42 Siena 9, 12, 15-17, 47, 50. 52-55, 72, 78, 88, 90, 101 Spoleto 12, 19, 81-82, 88, 91, 93

Tempio di San Biagio 72 Todi 12, 81, 83

Villa Medici di Poggio a Caiano 45 Volterra 9, 12-15, 54-55, 59-60,88

72, 79, 87-88

Piazza IV Novembre 77